NEIL S. KAPLAN

IMAGES
of America
PORT CHICAGO

The picture once painted or the poem sung, it stands henceforth by itself; the artist can do no more for it. It must live or die without further help from him. But the city is never thus entirely separated from us, its builders. It remains tied to us by the invisible cord of nourishing passions. It grows with us or it dies with us. It is in a more real and personal sense, a part of us as we are a part of it. It becomes then the reflex of the lives and aspirations of the people who dwell in it. . . . It is this the living spirit that may hearten and inspire us; that may delight and enchant us, and that may also break and destroy us.

—Temple Scott, San Francisco, 1922

ON THE COVER: Port Chicago was always a kid's town. In this 1937 view to the northwest, Woody and Lois Grover pose with their aunt Bobbi Gillian in the hills above their town. (Courtesy Keith Grover.)

IMAGES
of America
PORT CHICAGO

Dean L. McLeod

Copyright © 2007 by Dean L. McLeod
ISBN 978-0-7385-5551-5

Published by Arcadia Publishing
Charleston SC, Chicago IL, Portsmouth NH, San Francisco CA

Printed in the United States of America

Library of Congress Catalog Card Number: 2007926874

For all general information contact Arcadia Publishing at:
Telephone 843-853-2070
Fax 843-853-0044
E-mail sales@arcadiapublishing.com
For customer service and orders:
Toll-Free 1-888-313-2665

Visit us on the Internet at www.arcadiapublishing.com

This book is dedicated to the preservers, singers, and writers of the word, who carry the memories of all who live, and also to the photographers. To my children, who have learned patience with my obsessions. And to my long-sought, newfound wife, Kris, for all your patience: I thank you. You make it possible and fun.

Contents

Acknowledgments		6
Introduction		7
1.	National Ghosts: A Living Community	11
2.	The Geography of Industry: Why Port Chicago Came to Be	25
3.	The Century Turns: Movers and Shakers	31
4.	The Company Town: Migrants and Town Builders	45
5.	By Any Name: The Great Depression and Survival	59
6.	A Nation Mobilizes: A Community Grows	69
7.	The New Age: An Explosion Rocks Port Chicago	75
8.	Port Chicago: A Nuclear History	83
9.	The 15-Year Siege: Won Hearts and Pacified Minds	99
10.	Another Trail of Tears: The Year of Evictions	115

Acknowledgments

It is impossible for a writer to properly acknowledge all those who have assisted in the preparation of a book. In the most general way, I can only say that everything within these covers is stolen (within the law) from someone else's effort. In most cases, the people below saved photographs or documents that made it possible for me to tell the story. Thanks to all the archivists who work daily to protect documents so that a historian mining for obscure details can have material from which to work. There are a number of previously unpublished sources used in the captions and chapter introductions. For full bibliographic references, please visit my Web page at web.mac.com/Dean_McLeod.mac.

The following are those individuals and organizations who provided me with information, photographs, or both: Josephine Bailey, Claudia Cardinet, Dan Colchico, John Garvey, Barbara Glenn, Woody Grover, Tim Harrison, Edith Vlach Hills, Michael A. Kroll, Marcia Ravizza Lessley, Jerry Lombardi, Jerry Robbins Michaels, Ken Rand, Laura Regester, Ward Shideler, Peter Vogel, Robert K. Wilcox, the Bay Point Historical Society, the Concord Historical Society, the Pittsburg Historical Society, the photograph archives of the National Archives, the Department of the Navy, the Naval Historical Center, the Washington Navy Yard, and finally Kathleen O'Connor, formerly of the National Archives San Bruno.

Special mention is given to those who struggled through the text to ferret out errors of content, clarity, spelling, and punctuation. They include Kris Carlock (my wife), Barbara Glenn, Ken Rand, Dennis Schnelzer, Peter Vogel, and the editorial staff of Arcadia Publishing.

INTRODUCTION

Port Chicago was an all-American town. Born at the beginning of the 20th century, it survives today only in the memories and emotions of its former residents. It is a place some call blessed, others call cursed. Go to a reunion the last Saturday in July. You will feel the strength of the community even 40 years after the federal government destroyed the town.

Port Chicago is no more. The people have gone their way; the U.S. Navy has gone its way. The land is still very active, struggling to survive and revive from its 20th-century uses. But that is another story. This pictorial book is written for the people who came, lived, loved, worshipped, and served their country, only to be sacrificed to the war needs of the nation.

Like many small towns in this country, big events on a national and international scale left their imprint on the people and the land of Port Chicago. It is a micro-history of federal power in the 20th century. As Richard White, author of *It's Your Misfortune and None of My Own: A History of the American West*, wrote, "In some basic ways the federal government created itself in the West. The West provided an arena for the expansion of federal powers that was initially available nowhere else in the country." This is the story of the practical use of that power in this community.

Some places, in retrospect, seem destined for power and greatness. Eventually full of movers and shakers, they become staging grounds for proclamations, trendsetters, and social movements. They fill with headquarters of banks, multinational corporations, and television networks. Other sections of ground are themselves moved and shaken. Port Chicago is just such a place. Looking back, it is as though the threads and ropes and mooring lines of a violent century were dragged through the guts of every man, woman, and child who lived there. It was always a place to park "stuff" before sending it on to its destination. Most of the stuff was pretty harsh.

To its inhabitants, Port Chicago was "our town," a place of family, school, church, the volunteer fire department, Easter parades, and patriotism. No one locked their doors. Between 1908 and 1968, residents created a close-knit community.

So where was this misty Port Chicago? Why did it come into existence? How did it start? Who settled it? What great events happened there? Who were the famous people who passed through? Why is it memorable? This book will touch on some of the answers to those questions.

The Chupcan tribe of the Bay Miwok culture had lived near the site of Port Chicago for millennia. After being dragged from their homes to Spanish missions in San Francisco and San Jose, less than 20 souls survived the Mission period. The remnants of that large native community just to the southwest of Port Chicago are yet to be personally identified and gathered.

Representatives of the U.S. Army held this specific land second. American and Irish migrants were among the first actual settlers under U.S. sovereignty. Interesting and detailed unpublished material is available on the families who settled from 1850 to 1900 between modern Concord and Pittsburg. That larger area was called the Bay Point School District and is treated by the present author in Images of America: *Bay Point*.

Heavy industrial activities began at what became Port Chicago in the last years of the 19th century. A major copper smelter briefly flared on the edge of the swamp in the early 1900s. That site would become ground zero for events to come.

A few families from the 19th-century ranching and farming community stayed. They granted the two sections of land upon which the Smith Lumber Company built the town in 1908. Smith brought Swedish and Norwegian families from Minnesota to work the mill. By 1910, some 70 families lived in the town. About the same time, the General Chemical Company, just east of Bay Point, became an employment magnet for Italians, Greeks, and other Europeans. For these first-generation immigrants, the place was a company town with a company-sponsored store, hospital, and social services.

In the second decade of the 20th century, yet more people came. Those who knew how to build ships arrived in 1918. Powered by a war-driven demand for Victory ships, San Francisco capitalists established the Pacific Coast Ship Building Company. Walter Burgess, frequently well positioned for Contra Costa County developments, spent federal money on building shipways near foundations used earlier to warehouse wheat. The deep water there was a blessing but also a curse. It could be considered a blessing because without the location, no town would have been founded. It only became a curse when those same geographic advantages led to the takeover of the land by the U.S. Navy.

For a quarter of a century, the unincorporated city of Bay Point prospered on heavy industry. Its settlers worked hard in the lumber mill, the small factories, and the shipyard. They built churches. They created community organizations. They had a justice of the peace. It was a blue-collar town full of regular folks.

The 1929 stock market crash brought some jitters to townspeople, but town leaders expressed optimism in 1931 with a chamber of commerce drive to transform the image of the place. Reflecting the desire to expand its heavy industrial base, F. G. Cox suggested (to unanimous chamber approval) a name change to Chicago. Federal bureaucracy scotched that idea and the town became Port Chicago. The hoped-for industrialization also ran afoul of a huge Federal Reserve–led contraction in available capital. An era of economic decline began a slow strangulation of Port Chicago that lasted 10 years.

America's eventual response to the gradual rise of Hitler in Germany and Tojo in Japan reinvigorated Port Chicago. The community, the docks, and the town itself exploded on the boom times that came with war. The wartime story of Port Chicago sets it apart from most small towns in the country. Its role in America's nuclear history has also never been fully known.

What was the "stuff" mentioned earlier that was parked on or near Port Chicago's waterfront through the century? That is the nut of this story. Where did it come from? Where did it go? What was it for? Who did it affect? Who moved it? Who brought it? The conflict around these questions creates a drama really quite extraordinary for a town so little known outside Contra Costa County, California.

Basic food was the first such item to be stored. From 1860 to the end of the century, California was a major exporter of wheat, particularly to England. Farmers in the Diablo and New York Valleys harvested their wheat and brought them in wagons to Hastings Dock (the future site of Clyde) and later to Seal Bluff Landing. The Grange movement played itself out here, as elsewhere. Coal, mined in the foothills to the southeast and carried by ship and train, passed by what became the town during the same era. For a brief time at the beginning of the 20th century, copper ore was shipped in, smelted near the docks, and sold in Europe.

By 1908, Bay Point had grown into a primary processing and shipping site for West Coast lumber. Within a couple of years, it sported a pioneering petrochemicals plant that participated in the transformation of the 1900s. A generation of locals made its living laboring in these heavy industries. In 1942, the U.S. Navy, attracted to the natural advantages of Bay Point and Port Chicago and facing the torrid demands for the transportation of munitions from the West Coast for the Pacific war, took 576 acres of the dock area and eventually over 12,800 acres surrounding the docks and inland to Diablo Valley. The stuff of the town eventually ended the lives of a

majority of those killed in the Pacific wars. Port Chicago became an unrecognized symbol of the local sacrifice that a community of blue-collar patriots were called on to make to protect the country from Japanese, Korean, Vietnamese, and Middle Eastern threats.

From perhaps 1944, and certainly from 1945, the stuff that came, stayed, and went at Port Chicago became far more lethal. As part of the most secret program in the country up to that time, Port Chicago became a main transshipment point for the nuclear age. As the program expanded, it became clearer to those responsible that national security interests trumped the needs of this small community. As the nuclear age got into full swing in the 1950s, the U.S. Navy felt growing pressure for more room and higher security. Mid-decade, it began a strategic economic and public relations war against the town of Port Chicago that took 18 years to implement. Finally, during the year of the Tet Offensive, the U.S. Navy succeeded in securing the safety of the people of Port Chicago by destroying their town. It needed to be done.

This is a pictorial history book—just images of an American town. The full story of the place deserves much more. Local historian Ken Rand is working now to complete his 600-page micro-history of the eviction of the town by the U.S. Navy. The most detailed version of the explosion at the docks in 1944 is available online from Peter Vogel. Robert L. Allen's story of the mutiny of some of the black stevedores has received considerable national attention.

The complete nuclear history of Port Chicago will take more space than this small book allows and will require further de-classification and analysis of federal documents going back 65 years. Although this time and place has been partially treated in Images of America: *Bay Point*, the photographs are new and the story of the town is told in much greater detail.

One
NATIONAL GHOSTS
A LIVING COMMUNITY

In general, local histories, and particularly those of the Images of America series, start at the beginning and conclude at some time in the recent past. This book begins at the end simply because there is no longer a Town of Port Chicago. There is, however, a living community. The Town of Port Chicago was legally put to an end in October 1967, when Congress approved a military budget that triggered eminent domain laws allowing for the expansion of the Concord Naval Weapons Station. The town was formally erased on February 1, 1969, the deadline for the last resident to leave.

So this first chapter describes the recent Port Chicago community. Some may consider it a stretch to describe a ghost town in the present tense. Yet, like the Bay Miwoks before them, many people of the town—and certainly the land on which it was built—survive to this very moment.

Port Chicago's population declined after the closure of Coos Bay Lumber Company. In 1940, it had a population of about 1,000. Walnut Creek had a population of 1,578, and Concord was at 4,373. At its height in 1954, Port Chicago had a population in the vicinity of 3,500 people. By comparison, Walnut Creek had grown to 26,397 and Concord to 56,626. Today those whose families grew up in Port Chicago number in the thousands again. Many still consider themselves comprising a community. Although geographically spread from Virginia to Salt Lake City to Northern California, they refer to themselves as Port Chicagoans.

Port Chicago is a national ghost town. By examining the history of this little place closely, one can begin to appreciate the divergent interest of federal power and local community. It can provide a keyhole through which to see 20th-century national history.

Each year for the past nearly four decades, 100 to 400 people have met at Ambrose Park in Bay Point, formerly West Pittsburg, to renew old friendships and remember the town they loved so much. The following pages memorialize a few of these people.

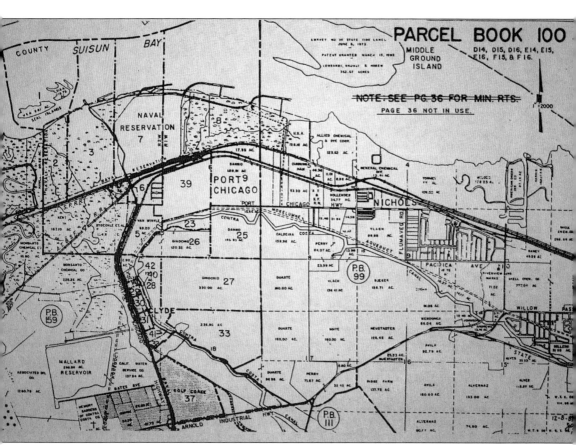

PORT CHICAGO AREA. This parcel map from the Contra Costa County recorder's office shows the community relationships along the waterfront between Nichols, Clyde, Port Chicago, West Pittsburg (now Bay Point), and the U.S. Navy's property. (Courtesy *Contra Costa County Recorder*.)

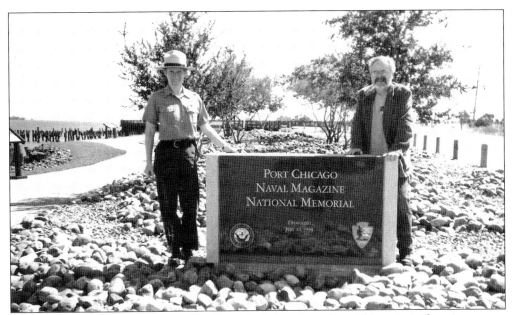

Port Chicago Memorial. Native Ken Rand (right), author of *Port Chicago Isn't There Anymore—But We Still Call It Home*, poses with a National Park Service guide near the site of the World War II explosion. A memorial honors the sailors, merchant marines, and officers who died in the blast. (Courtesy Ken Rand.)

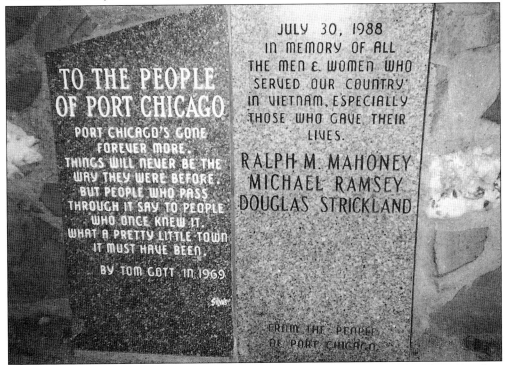

People's Memorial. For nearly 40 years, the people of Port Chicago have gathered to remember. In 1988, they unveiled the only memorial to the town's fallen during the Vietnam War. (Courtesy Ken Rand.)

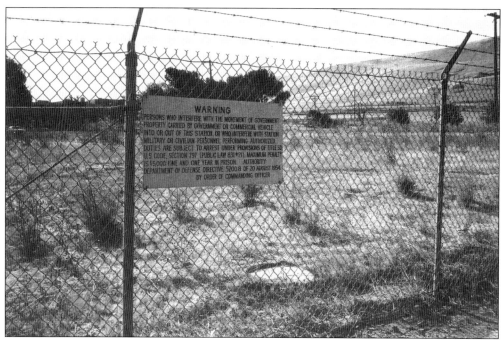

BUILDING A FENCE. The former site of Port Chicago has been surrounded by fencing like this for nearly 40 years. Certain areas include barbed wire within barbed wire within barbed wire, accompanied by guard towers. Those spots are not recommended for the casual visitors of today. (Courtesy Ken Rand.)

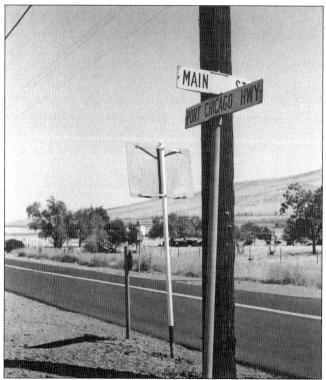

A REMEMBERED CROSSROAD. This 1985 view of Main Street, looking southeast, shows the section of Port Chicago Highway from Mereen to Carroll, which was called Division Street. (Courtesy Ken Rand.)

MAIN STREET IN 1985. Few town buildings survived the U.S. Navy's takeover. Later the Contra Costa Board of Supervisors sold Port Chicago Highway to the U.S. Navy, which closed the former thoroughfare off to public access. (Courtesy Ken Rand.)

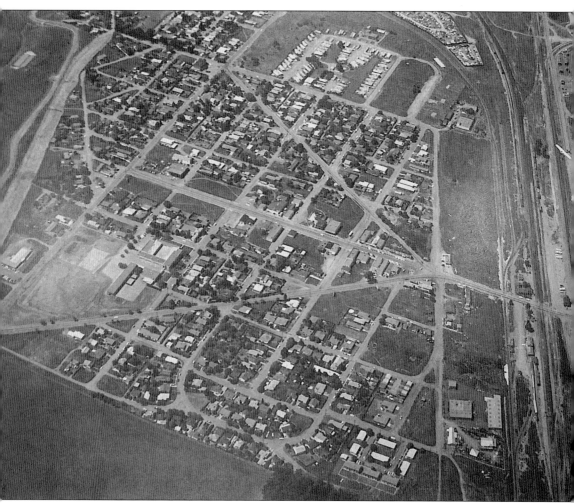

WHAT THEY TOOK. This aerial view of Port Chicago at its apex gives an accurate sense of its substantial nature. Although largely forgotten as a town by Bay Area natives and completely unknown by newcomers to Contra Costa County, it was a real town—not just a neighborhood. (Courtesy Ken Rand.)

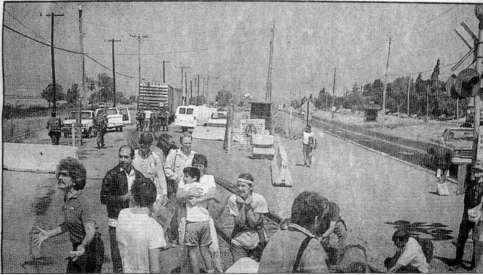

BRIAN WILLSON. Few images demonstrate more clearly the collision of fundamental ideas of war and peace at Port Chicago than this 1987 view of protesters at Clyde. This photograph was taken moments after a munitions train purposefully ran over Vietnam veteran Brian Willson. The well-publicized protest concerned President Reagan's Iran-Contra munitions shipments. The ghosts of global wars past and oil wars present hang over the place. (Courtesy *Contra Costa Times*.)

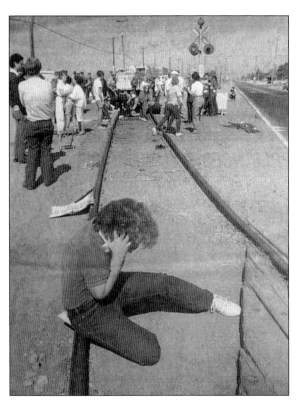

MICHAEL A. KROLL'S GRIEF. Moments after he watched as his friend Brian Willson was run over by the munitions train, Kroll collapsed in horror. The protest plan for a human blockade of the tracks was hatched in Kroll's kitchen in Oakland. Most Port Chicago residents had no associations with war protesters. (Courtesy *Contra Costa Times*.)

THE PEOPLE SPEAK, 2006. Among the signs greeting the reunion crowd, this one captures the feelings today among those who grew up in the town. (Courtesy Dean L. McLeod.)

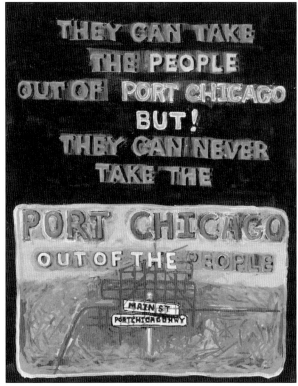

Port Chicago

This is the site of my city,
A city of peace and contentment
Home of the industrious and friendly
Wishing only to be left to their duties;
To beautifying the homes they had builded,
To raising their families in comfort,
To living the lives of good people
And to contributing to the wealth of the nation
Till the cruel forces of the Navy,
With malicious and lying inventions
Destroyed the city forever
With dozers and dozers and dozers.

Where are the people of my city?
The people who fought so bravely
Against an enemy so powerful,
Against an enemy so unprincipaled,
As to think only of wanton destruction?

Scattered like dust and leaves
Are the people of my city--
Scattered but not beaten in spirit
Are the people of my city.
Gone are the voices of children,
Gone is the laughter of maidens.

Still stands the site of my city,
Still reigns the spirit of the people
Who so gallantly fought for a principle.
Still blow the murmuring breezes,
Still lap the waves on the beaches,
Still stand these forces forever;
Not even the powerful Navy
Can ever find ways to conquer,
Can ever find ways to destroy.

December 22, 1969
by Roy E. Lee
Principal Bay Point
School

RECORDING LOSS. Roy E. Lee, principal of the Bay Point School, remained until after Port Chicago was closed to express how most felt about having their town "taken." (Courtesy Dean L. McLeod.)

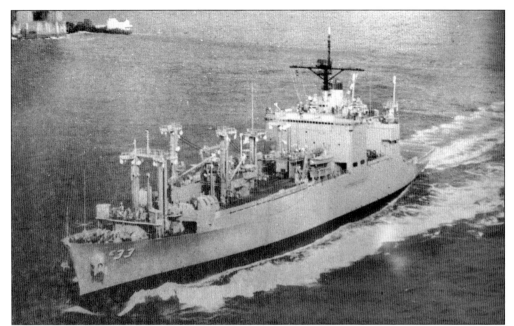

USS SHASTA (AE-33). Like its sister ships in the Kilauea class, the *Shasta* was named after a volcano. After Port Chicago was closed, these ships supplied the Pacific Fleet with munitions from docks near modern Bay Point. Seven ships of the same class were home-ported here during parts of the third quarter of the 20th century. The *Shasta*'s duty was among the most dangerous in the U.S. Navy. (Courtesy Kris Carlock.)

BASE OPERATIONS IN THE 21ST CENTURY. This view was taken from modern Bay Point. Although munitions storage has been largely curtailed, especially since the closure of the inland portion of the Naval Weapons Station in 1998, readiness continues at the new containerized docks. Now called the Military Ocean Terminal Concord, the docks are operated by the Military Traffic Management Command. Among the projected stuff for intended transshipment are radioactive spent nuclear fuel rods. (Courtesy Dean L. McLeod.)

MARCIA RAVIZZA GATHERING THE TROOPS. Marcia Ravizza Metcalf (now Lessley), whose grandfather came to Bay Point before 1910, makes announcements at an early Port Chicago reunion in Ambrose Park. (Courtesy Marcia Ravizza Lessley.)

ART CHOMER, COMMUNITY STALWART. Art Chomer, who participated in and led numerous organizations throughout his life in Port Chicago, speaks at a reunion in the 1980s. (Courtesy Marcia Ravizza Lessley.)

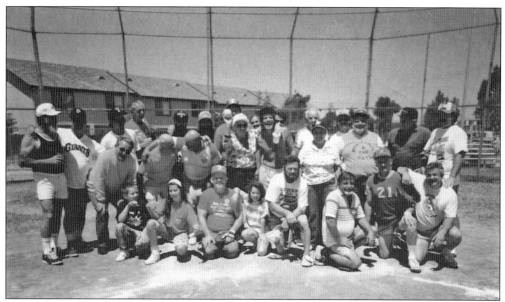

OLD-TIMER'S GAME. A regular feature of the reunions has been an old-timer's softball game. Those shown here are Reno Pivo, Leo De Marco (squatting, in shades), Kenny Lombardi, (bald, left), Paul Lang (behind Kenny), Jerry Lombardi (balding, right), Hornbuckle (behind Jerry), Jo Graham (umpire with ball), and Fibber McGee (kneeling, in the Bay Point–Port Chicago T-shirt). The rest of the group comprised the opposing team, the Golden Gates. Others who often played for Port Chicago were Jimmy Foster, Craig Sims, Jim Powell, Ray Law, and Reno De Marco. (Courtesy Marcia Ravizza Lessley.)

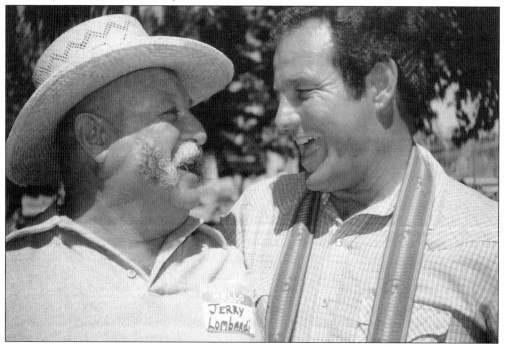

FOSTER AND LOMBARDI. Jerry Lombardi (left) and Jimmy Foster greet each other at a reunion around 1984. (Courtesy Marcia Ravizza Lessley.)

OLD-TIMERS TOGETHER. Leo Reese and Marge Gott enjoy basking in the sun of the last Saturday in July. (Courtesy Marcia Ravizza Lessley.)

AMBROSE PARK, 2002. Pictured here, from left to right, are Daniel Colchico, Lefty Butler, Joe Colchico, Dan Colchico, Nancy Colchico, Pat Butler, and Sharon Metcalf. (Courtesy Marcia Ravizza Lessley.)

LOUIE GROSSI AND WALT SHIDELER. In 2004, Shideler, the grandson of the developer of Bay Point, shows Grossi photographs depicting the 1908 construction of the original town. (Courtesy Dean L. McLeod.)

Two

THE GEOGRAPHY OF INDUSTRY
WHY PORT CHICAGO CAME TO BE

Port Chicago came into being because of its convenient shipping location. The waterfront at Bay Point had for millennia sat along a river whose shores were adjacent to the modern deepwater channel. The end of the Ice Age 11,000 years ago raised the sea level around the Bay Area by some 300 feet, moving the shoreline to where it is now.

The modern shape of the bay and the depth of the water made it a convenient anchorage first used by Spanish explorers in 1776. Spanish, Russian, French, and American fur traders used Suisun Bay during the early 19th century. Between 1849 and 1850, the first U.S. Navy surveys were completed and buoys were placed around the Seal Islands.

Aside from the Civil War, the building of the transcontinental railroad was the largest economic story of the second half of the 19th century in America. Where its rails went, opportunity followed. From the Sacramento terminus, the cry was to extend the railroad to the coast and the waiting San Francisco. Two railroads would wind around the hills through which Willow Pass was later carved, becoming a convenient transportation site.

Hon. Serranus Hastings, first chief justice of the California Supreme Court, purchased the most advantageous spot for grain shipping in central Contra Costa County. His ranch, built in 1860, eventually included a warehouse on the slough named for him. Situated at what became Clyde, he had control of access to the deep water. Farmers paid him to store and ship their grain. By the 1870s, local ranchers and farmers wanted to work around Hastings. After a drawn-out court battle, a road was constructed, and the best shipping point followed a thin strip of dry land out to deep water. That small protuberance of dry land called Seal Bluff eventually was expanded by fill dirt until the whole section could be used for industry.

The land around the old town is magnificent. It is also very ill. The current uses of the land are not much different from those of the past century, other than the fact that there is no residential habitation. Oil, natural gas, water, gasoline, jet fuel, chemicals, and weapons all pass through. For now, it remains an active shipping port. A strong possibility exists that the docks' new container facilities will be used in the transshipment of radioactive nuclear fuel rods.

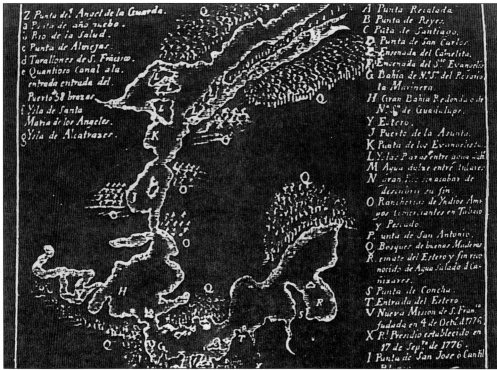

MAP OF THE BAY AREA, 1776. The Spanish made this map the same year the American Revolution began. Rotated right, it shows some detail of the area that would become Port Chicago. To the left of the word *Angeles*, Suisun Bay is visible, its islands marked with an "L." To the far left, the swamps of Diablo Valley are depicted, along with the placement of a Native American village. (Courtesy Bancroft Library.)

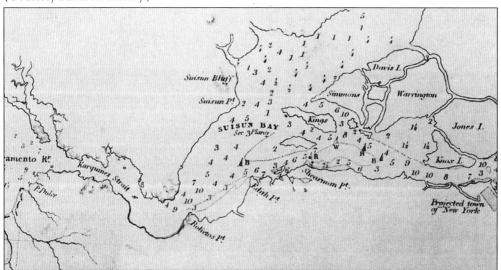

SUISUN BAY AND DELTA, 1850. This map was likely part of the *Coast Survey of San Francisco Bays* by William P. Humphreys. Notice that the first name for Bay Point was Shearman's Point, after a young officer later to be known as Gen. William T. Sherman. The water near the Seal Islands was 18 to 36 feet deep. (Courtesy Bancroft Library.)

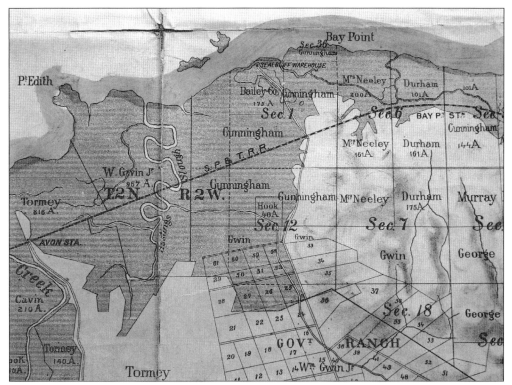

SITE OF PORT CHICAGO. By 1885, the transportation and communications value of the area was well known. As the map shows, the first railroad arrived with a station at Bay Point, and the water routes and road were clearly delineated and platted. (Courtesy Dean L. McLeod.)

MODERN CLYDE AND PORT CHICAGO. Looking northwest from the hilltops near Port Chicago Highway in the Clyde area, this view shows the barren hills to Port Chicago's east. In the distance at the right are the white loading cranes at Concord Naval Weapons Station. (Courtesy Dean L. McLeod.)

EARLY CONTRA COSTA COUNTY. This c. 1880 map from the lithography firm Smith and Elliot reveals the original Spanish land grant names of Contra Costa County. Most are no longer in use, but some, such as Los Medanos—the original name of the region including nearby Pittsburg—live on, as evidenced by that city's Los Medanos Community College. (Courtesy Contra Costa County Historical Society.)

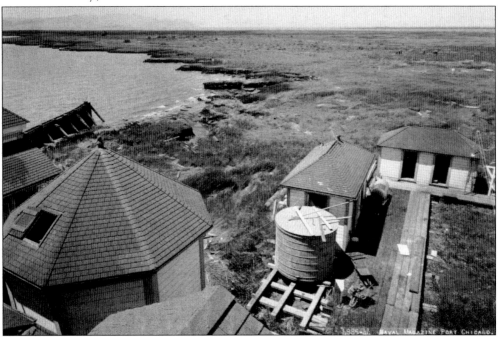

SUISUN BAY ISLANDS. This 1944 view of the Roe Island lighthouse shows the marshy, inhospitable shoreline that greeted early settlers to the Port Chicago and Bay Point areas. (Courtesy Sierra Pacific Region, National Archives.)

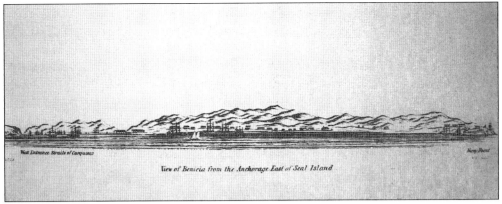

RINGGOLD'S VIEW FROM SEAL BLUFF ANCHORAGE. Cadwalader Ringgold completed a detailed survey of the entire Bay Area, including buoys and detailed navigational aids, past what became Port Chicago. He wrote that in November 1850 he arrived at Benicia, where he found "Lieutenant McArthur, of the Ewing," surveying the vicinity for the selection of naval and military depots. He described the excellent anchorage just east of the Seal Islands. (Courtesy Cadwalader Ringgold.)

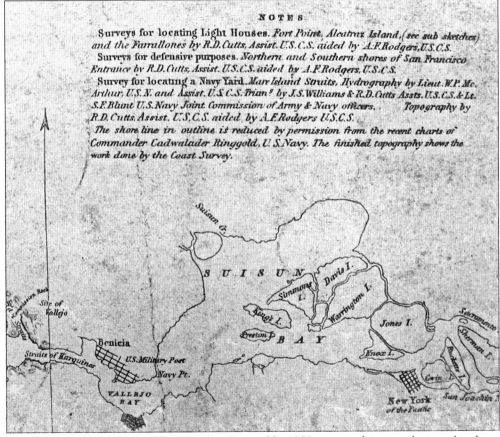

RINGGOLD'S MAP. Created shortly after Ringgold's 1850 survey, this map depicts the then-unnamed site of Port Chicago, just below Preston Island. (Courtesy Sierra Pacific Region, National Archives.)

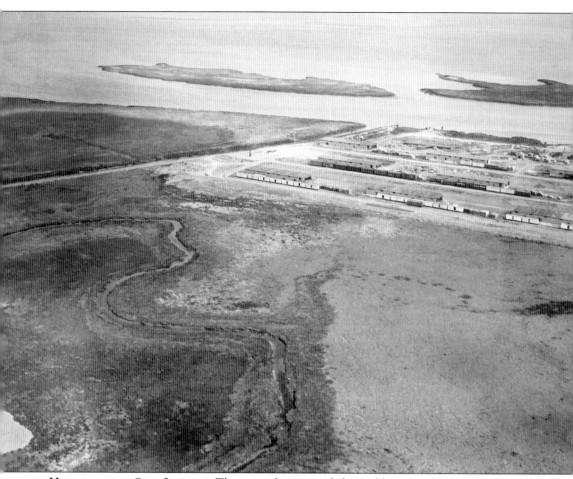

HASTINGS AND SEAL ISLANDS. The natural, protected channel between the mainland and the small Seal Islands provided a perfect anchorage for the port. (Courtesy Sierra Pacific Region, National Archives.)

Three

THE CENTURY TURNS
MOVERS AND SHAKERS

San Francisco boomed after the depression of 1893. British investors seeking raw materials wanted a site for a copper smelter. With the triple advantage of deep water, two railroads, and a county road leading to the docks, Seal Bluff fit the bill. Thus, the Copper King Smelter came to Contra Costa. The 1903 national capital contraction crippled the Cunningham brothers, however, who were left holding a $50 debt.

The San Francisco earthquake of 1906 triggered the reuse of the waterfront. Charles A. Smith, who had been acquiring timber rights throughout California and Oregon for $1 an acre, saw great opportunity for rebuilding the destroyed city of San Francisco. As trainloads of rubble from the quake damage filled the waterfront at Hastings Slough and Seal Bluff, the new industrial adjunct of town became the processing area for rough-cut wood. According to Walter Shideler, his grandfather Frank persuaded Smith, a protege of Minnesota governor John S. Pillsbury, to locate a massive lumber processing facility here and to acquire the Copper King Smelter buildings. Smith was able to purchase sufficient land from the Cunningham heirs to lay out a large plant and provide the county with plans for a new town.

Big Oil came to the Bay Area at the same time, to the west of the new town of Bay Point and across the bay near Benicia. General Chemical arrived in 1910 and built its own company housing called Nichols, after the capitalist chemist William H. Nichols. At the outbreak of World War I, Irving M. and Henry T. Scott formed a new firm to manage a contract to build Liberty ships for the war effort. Pacific Coast Shipbuilding moved in alongside the Smith Lumber Company in Bay Point. Contra Costa County man Robert Burgess obtained federal money to construct housing for the ship workers, creating Clyde on his own land (formerly Government Ranch), and backed the electric train that traveled through Clyde to the docks.

Walter Van Winkle and his wife, Eunice, also moved over to Bay Point from Berkeley when the war broke out. They formed the Bay Point Land Company, eventually controlling the water and power coming into the town as well as much of the real estate. Of all these movers and shakers, only Shideler and Van Winkle settled in the town.

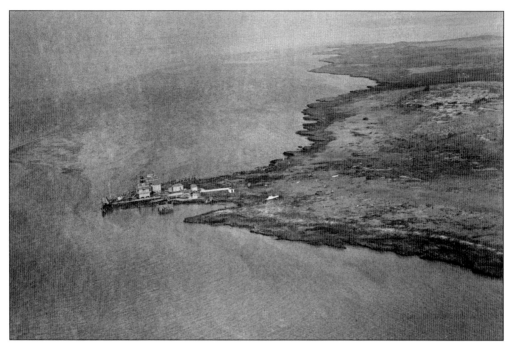

ROE ISLAND LIGHTHOUSE. In February 1891, the U.S. Lighthouse Service, the forerunner of the U.S. Coast Guard, built this lighthouse to serve ships running through the difficult Suisun Bay. In the 1930s, the lighthouse keeper was Englishman Harry H. Hoddenott, or "Old Man Nuttman" to the local teenagers. The house was badly damaged in the explosion of July 1944 and sold as surplus. (Courtesy Sierra Pacific Region, National Archives.)

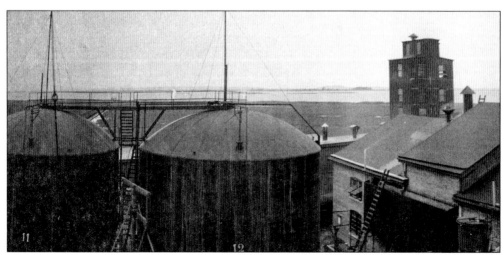

CHEMICAL TANKS. General Chemical, which used these huge tanks for chemical storage, was a pioneer of the West Coast petrochemical industry. (Courtesy General Chemical Company, Bay Point.)

COPPER KING SMELTER. The first heavy industry in what would become Port Chicago was the Copper King. It was one of numerous British companies in California at the end of the 19th century. Its story is dealt with in some detail in Images of America: *Bay Point*. (Courtesy Contra Costa County Historical Society.)

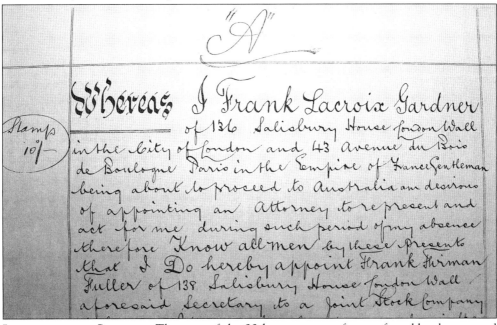

INTERNATIONAL SCANDAL. The start of the 20th century was famous for robber barons and scammers. Frank Gardner seems to have been just such a person. His friend Madame Concepcion Benitez de Beistegui, of 136 Avenue des Champs Elysees in the city of Paris, had been loaning him money to keep the smelter going. The ground on which Port Chicago would eventually prosper was witness to the disappointment of many creditors and workers when Gardner took the money and fled to exile in Australia. (Courtesy Sierra Pacific Region, National Archives.)

OLD-GROWTH TIMBER. Bound for Bay Point, this fallen spruce giant near the south inlet camp of the Smith-Powers Logging Company is one of thousands still to be found in San Francisco houses. This tree was 11 feet in diameter at the stump. (Courtesy *American Lumberman*, 1911.)

SMITH HOLDINGS. This map shows the massive timber rights acquired (generally for $1 per acre) by the Smith Lumber Company at the start of the 20th century. Huge timber stands in Lincoln, Linn, and Douglas Counties in Oregon and Humboldt and El Dorado Counties in California were "tributary to the great manufacturing and distributing plant at Bay Point, California." (Photograph and quote from *American Lumberman*, 1911.)

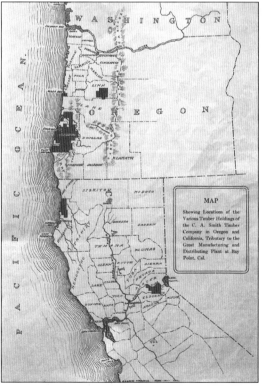

THE BOSS. Frank Shideler grew up the son of a miller in Warren County, Indiana. By the 1890s, he owned a share of the Red Cap Gold Mine in Arcata, Humboldt County, California, and was selling land there. Coincidentally, the Charles A. Smith Lumber Company had large timber holdings just north of Arcata at about the same time. After the 1906 earthquake, Shideler persuaded Smith to create the town of Bay Point and a lumber processing facility there. One of Shideler's jobs in early Bay Point days was to hire ferries to bring possible investors from San Francisco to the budding Bay Point. (Courtesy *American Lumberman*, 1911.)

SHIDELER FAMILY AT HOME. Before coming to Bay Point, the extended family lined up in front of its grain mill in Warren County, Indiana. Town creator Frank sits center, second from left. Born in Attica, Indiana, in 1881, he was a promoter by occupation. According to his family, he was always on a cross-country train. Frank was working in San Francisco when the 1906 earthquake hit. (Courtesy Ward Shideler.)

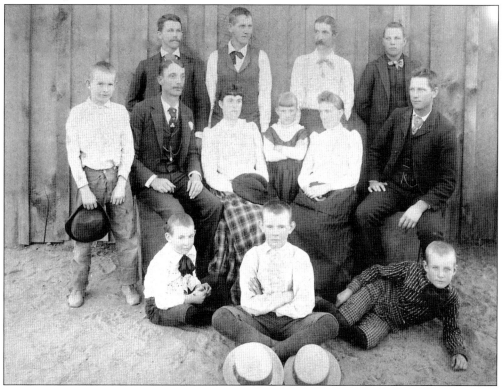

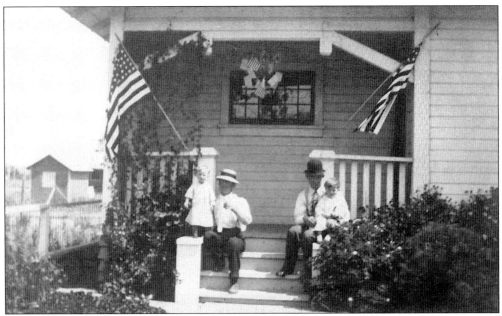

FOURTH OF JULY, 1912. Sam Shideler (left) and his father, Frank, hold two of Sam's children, Ella Mae and Vivian. Sam served as the Hartford Insurance agent in Bay Point for many years. He and his family lived on West Lind, now Port Chicago Highway. (Courtesy Ward Shideler.)

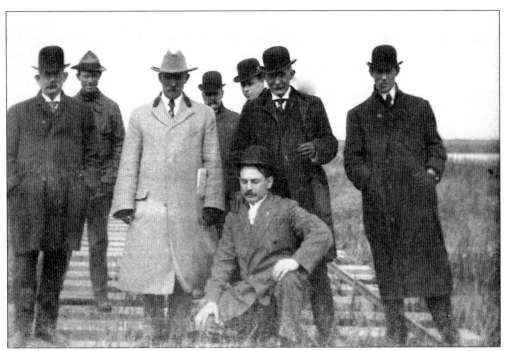

FOUNDERS OF BAY POINT. These are the founding visionaries, industrialists, engineers, and promoters of the Smith lumber facilities and the town. This photograph, found in the Shideler family album, does not provide names. (Courtesy Ward Shideler.)

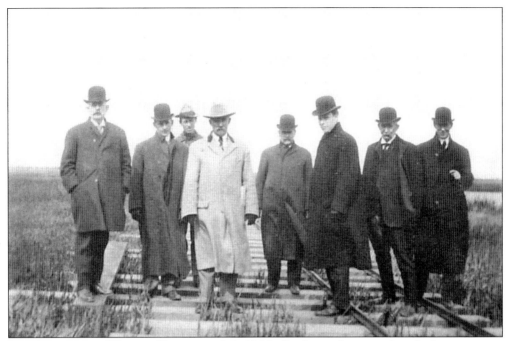

INSPECTING THE WHARF, FEBRUARY 26, 1908. By dress, these unidentified men appear to be some of the big bosses, inspectors, and at least one of the engineers or yeomen of the operation. After inspecting the dock, they are returning across the temporary walkway. (Courtesy Ward Shideler.)

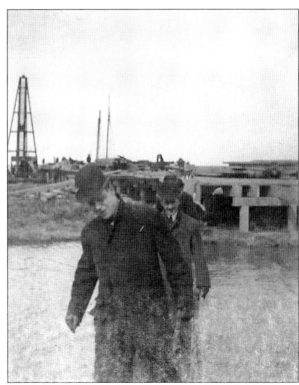

WALKING THE PLANK. The inspectors gingerly cross a walkway, careful not to fall into the muck. The swampy earth around Port Chicago and Bay Point made for difficult construction and navigation in the early years. (Courtesy Ward Shideler.)

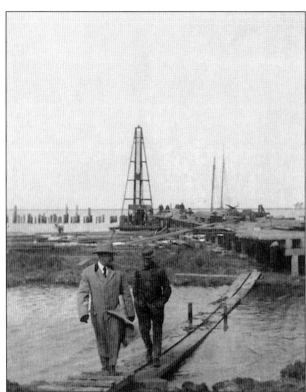

SAFELY ACROSS. In this view, two of the bosses have made it across the temporary walkway. In the background, substantial progress on the pier construction is evident. (Courtesy Ward Shideler.)

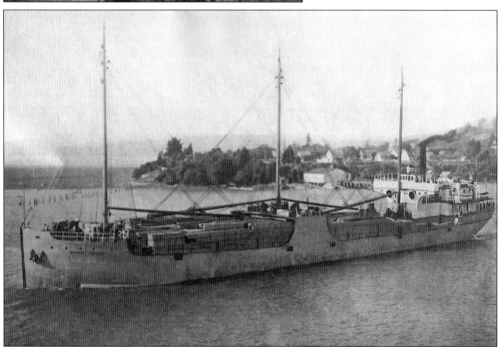

NANN SMITH DEPARTING. Named after the wife of Charles A. Smith, this modern freight carrier was able to carry 1.5 million pounds of timber. The steamship is shown here leaving Marshfield, Oregon, for Bay Point about 1910. (Courtesy General Chemical Company, Bay Point.)

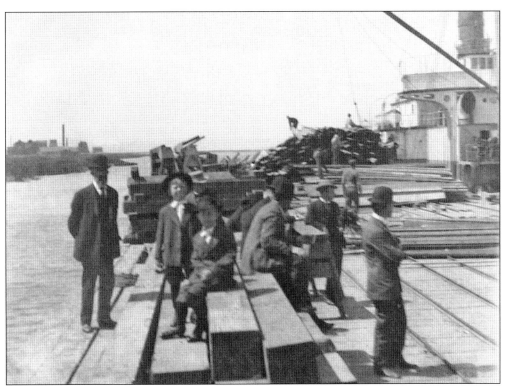

WATCHING UNLOADING. Around 1908, the camera catches the unloading of the *Nann Smith*. Five businessmen and three young boys watch as seven workmen wrestle with lumber on the dock. The defunct Copper King Smelter is visible in the left distance. (Courtesy Ward Shideler.)

BOTH TRAIN DEPOTS. Charles A. Smith saw the advantage of both the Southern Pacific and Santa Fe Railroads running parallel to one another through the village of Bay Point. These two railroads established transfer and storage yards to accommodate the Smith operation. (Courtesy *American Lumberman*, 1911.)

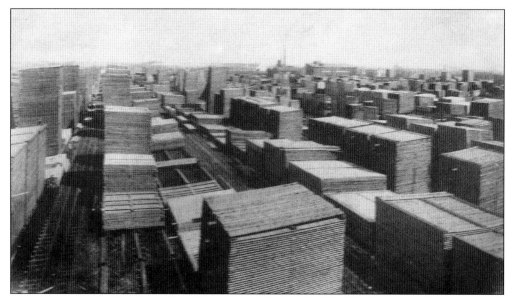

DRYING LUMBER. About 20 million board feet of lumber was carried in stock at Bay Point before the Depression. The lumber was distributed to dealers in San Francisco, Oakland, Berkeley, and Richmond by barges and to the Salinas, San Joaquin, and Sacramento Valleys by truck and railway. High-grade stock was shipped by rail east of the Rocky Mountains. (Courtesy *American Lumberman*, 1911.)

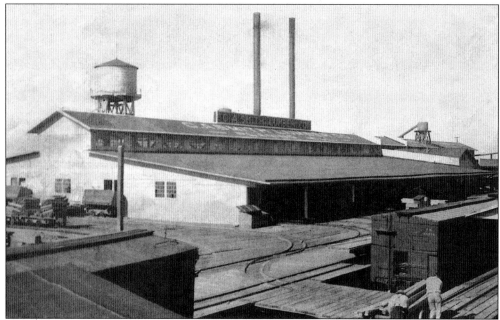

THE PLANING MILL. Prior to the Depression, lumber provided the greatest employment in Bay Point. It also created the need for services. Sam Shideler was instrumental in establishing a fire district in Bay Point. The three commissioners were S. W. Cunningham, Andrew Shirpke, and G. Erickson. A steam siren would sound at the lumber company, and young boys and volunteer firemen would push hose carts to the fire. Hydrants brought water from the reservoir on the hill. (Courtesy *American Lumberman*, 1911.)

DAN C. DESMOND. Living in Bay Point in 1911, Desmond worked as the sales manager of the lumber operation. (Courtesy *American Lumberman*, 1911.)

Dan C. Desmond, of Bay Point, Cal.; Sales Manager C. A. Smith Lumber Company.

GENERAL CHEMICAL COMPANY. William H. Nichols (1852–1930) is known as a pioneering leader in the fledgling chemical industry of the late 19th and early 20th centuries. The best known of the firms he organized was the General Chemical Company, which merged with four others to form the Allied Chemical and Dye Company (known as the Allied Signal Corporation). The Nichols Medal has been granted to more than 97 chemists since 1903. (Courtesy General Chemical Company, Bay Point.)

Louis B. Berglund, of Bay Point, Cal.; Superintendent of the C. A. Smith Lumber Company's Plant.

LOUIS B. BERGLUND. Living in San Francisco, Berglund served as the superintendent of the Bay Point plant in 1911. (Courtesy *American Lumberman*, 1911.)

SMITH ENGINEER. This photograph shows the engine room of the powerhouse. The engine, producing 500 horsepower and running all of the facility, sat on a concrete foundation weighing 160 tons. (Courtesy *American Lumberman*, 1911.)

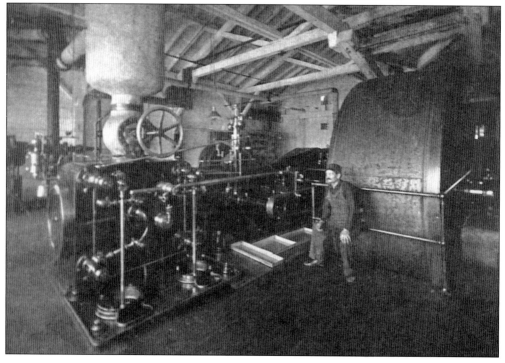

ARNO MEREEN. Born in Maine in 1858, Mereen started his career as a sawyer and, by 1900, had become manager of the Smith Lumber Mill in Minneapolis. He designed some of the heavy equipment at the Bay Point plant and served as both vice-president and general superintendent of the entire company. Mereen and his wife, Edith, continued to live in Oakland after the Port Chicago plant had closed. (Courtesy *American Lumberman*, 1911.)

BAY POINT PLANING MILL INTERIOR. This mill was advertised in 1911 as the largest and best equipped in the country. It handled fir, Port Orford cedar, and spruce timber. (Courtesy *American Lumberman*, 1911.)

Arno Mereen, of Oakland, Cal.; Vice President and General Superintendent of the C. A. Smith

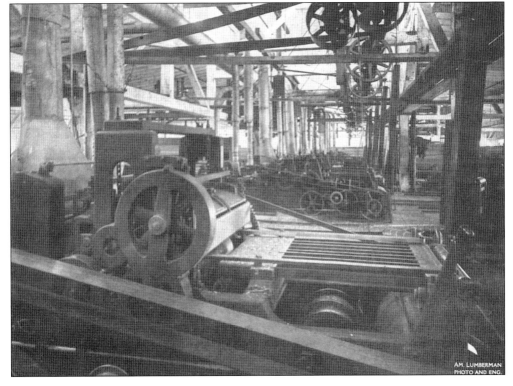

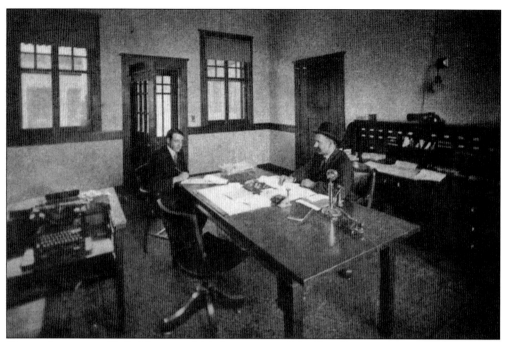

OFFICE INTERIOR. C. A. Hartman (right), manager of the Box Department, and his assistant, Arthur J. Voye, are pictured here in 1911. Hartman had extensive experience in Chicago, Illinois, and in Washington State. (Courtesy *American Lumberman*, 1911.)

WATER PLAN, 1919. The *Contra Costa Gazette* first proposed building a naval base on Suisun Bay in 1916. Citing the fresh water port, the immunity from sea attack, and the nearby industrial facilities, the *Gazette* compared the bay with the Dardanelles for impregnability: "The perfection of this body of water for such a purpose has long been known to the men entrusted with shaping affairs pertaining to national defense." (Courtesy Contra Costa County Historical Society.)

Four

THE COMPANY TOWN
MIGRANTS AND TOWN BUILDERS

The development of heavy industry at the dawn of the 20th century was a watershed in American society. It drove the country from a largely agricultural-based economy toward urbanization. In Contra Costa County, it brought a substantial transformation in demographics and had a lasting impact on local politics. For the first time, the board of supervisors dealt with national and international corporations. Leaders in the petrochemical industry brought massive changes to the waterfronts along the bays in the county. There is much room for research into this evolving relationship. A key player for most of the century was the Contra Costa Development Association, which later evolved into the Contra Costa Council. The former organization began its lobbying work fairly early in the century.

The petrochemical corporations brought their money, factories, and people to Bay Point. They found their own employees and transferred them from industrial operations back East. The Swedish Charles A. Smith transported most of the lumber workers from his plant in Minnesota. By the time of the 1910 census, 70 families lived in the town, most of Scandinavian descent. The Chemical Works at Nichols imported mostly Italians and Greeks. The railroad under construction through Bay Point that year employed 66 workers, all but two of whom were Mexicans.

The vast majority of these people were new to California. Most came directly from Europe, or were of European descent. In some ways, they remained distinct from the agricultural families who had been in the county for 50 years. From 1932, with the exodus of the majority of the Scandinavians, the town's demographics shifted more strongly to those of Italian heritage.

SAMUEL BACON. One of Contra Costa's early captains of industry, Bacon first set up a mule stable in the 1850s for the army and later served as postmaster and notary public for Port Chicago and other communities. (Courtesy Contra Costa County Historical Society.)

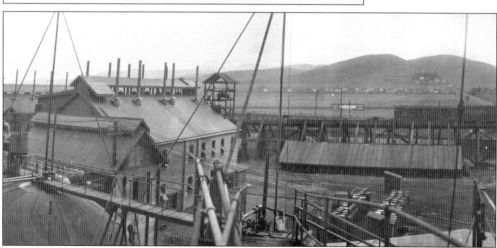

FIRST NICHOLS HOMES. Taken from a gangway, this westward view shows the budding neighborhood for workers at General Chemical. The now-vacant area is part of the U.S. Navy's security buffer zone. To the right, outside the frame, the army currently runs a high-security shipping port. The hills to the left are now covered with housing developments. (Courtesy General Chemical Company, Bay Point.)

CHARLES AND ANN MURRAY. This Irish couple came to California in 1858 and had settled in Section Eight of the Bay Point District by 1868. They first did their business in Concord and eventually at Cunningham's Store in Bay Point. Ann's sister Frances married Daniel Cunningham. (Courtesy Edith Vlach Hills.)

WILLIAM CUNNINGHAM AND MARY FAHY. William and Mary wed at Whistling Winds, his father's Bay Point ranch, in 1886. The couple had moved to San Francisco by 1910, and William became a hay and grain merchant. (Courtesy Edith Vlach Hills.)

SIMON CUNNINGHAM, 1910. Simon stands in front of his saloon–general store. At the start of the 20th century, it was the only retail store in Bay Point. Simon's father, Daniel, came to California very early and settled before 1859 on the land that would become Port Chicago. Daniel died in 1900. (Courtesy Laura Regester.)

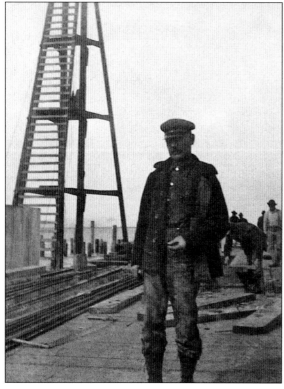

GANG BOSS SAMUEL GILROY. Born in Canada of Irish parents, Gilroy supervised much of the actual work on the construction of the lumber facility. One of his first tasks was to oversee the building of the shipping dock. (Courtesy Ward Shideler.)

DINNER BELL. The laborers at the Smith Lumber Company were called to dinner by this gentleman, who probably also prepared the meals. (Courtesy *American Lumberman,* 1911.)

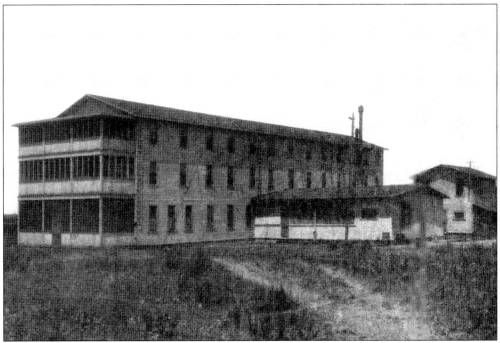

SMITH BARRACKS. In the earliest years, single men came to work at the lumber company. This "hotel" was the first building constructed at Bay Point to provide bachelor housing. (Courtesy *American Lumberman,* 1911.)

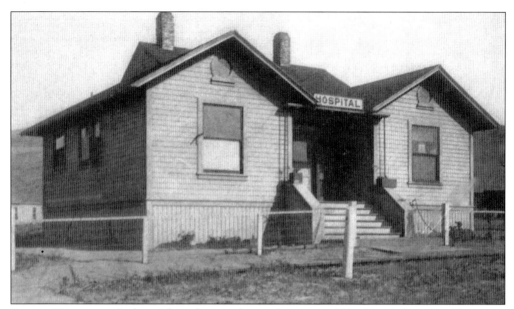

SMITH HOSPITAL. Industrial work was always dangerous. The Smith Lumber Company provided the most close-at-hand medical aid for laborers and their families. When the lumber company closed, Louis Grossi remodeled the hospital into the family home. (Courtesy *American Lumberman*, 1911.)

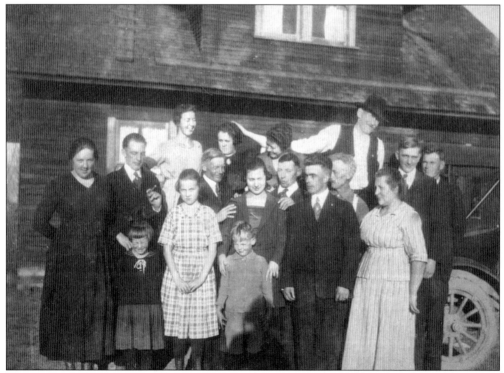

SWISS AND SWEDISH SETTLERS. This photograph of some of the Soderlunds was taken in the 1930s. Five of the group pulled a prank on the photographer. Notice the length of arm in the back row. (Courtesy Marcia Ravizza Lessley.)

THREE SISTERS. Taken around 1915, this photograph shows three Soderlund sisters: Bertha (left), Beda (center), and Emily. Their family came to Bay Point about 1908. (Courtesy Marcia Ravizza Lessley.)

ITALIANS TO BAY POINT. By 1910, about 31 Italian families were living in or near Nichols and working at the General Chemical Company. Many of them were *contadinos* sponsored by family. Domenico and Julia Grossi had made it to Bay Point from San Giovanni, Italy, by 1917. This photograph was taken at their marriage in the Old Country. (Courtesy Marcia Ravizza Lessley.)

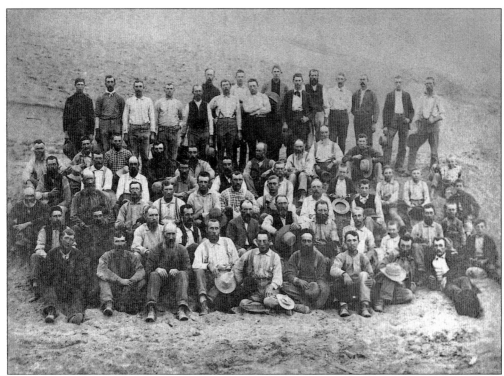

BUILDERS OF SMITH LUMBER COMPANY. Although these laborers are not identified, the lumber workers listed in the 1910 census can be viewed online at web.mac.com/Dean_McLeod.mac. (Courtesy Marcia Ravizza Lessley.)

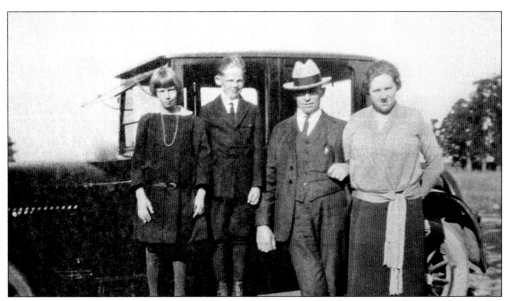

RAVIZZA FAMILY. Bertha Soterlund was born in Lidensboda, Sweden, in 1890. Her family traveled first to Minnesota and then to Bay Point. Shown here in the 1930s are, from left to right, Jeanette, Burt, and their parents, Eugene and Bertha Ravizza. Bertha died in the new Port Chicago in 1938. (Courtesy Marcia Ravizza Lessley.)

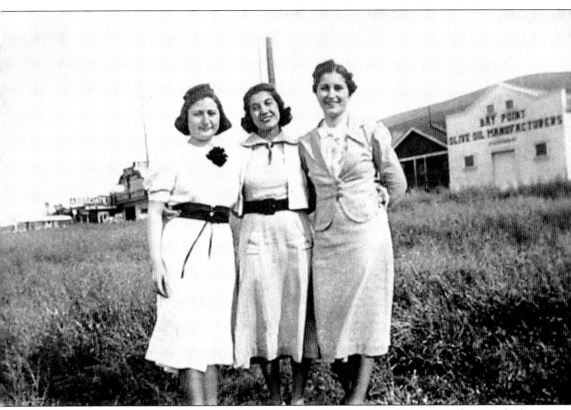

BAY POINT OLIVE OIL. Pictured here are local workers Zampia, Urania, and Christine, photographed in April 1938. (Courtesy Marcia Ravizza Lessley.)

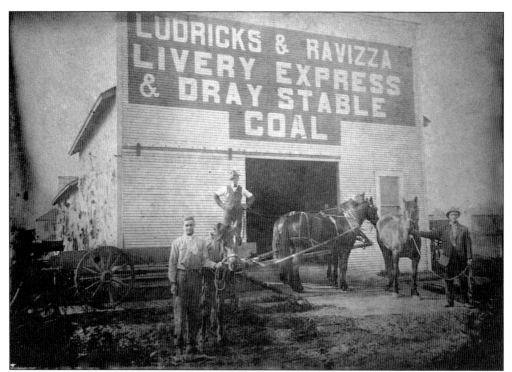

LUDRICKS AND RAVIZZA LIVERY. William Ludricks, whose father emigrated from Portugal in 1884, worked first as a farm laborer and partnered with Eugene Ravizza in the livery between 1910 and 1915. In 1910, Ravizza had been a stockman in Elko, Nevada. Ravizza stands on the porch, while Ludricks poses with the horse. (Courtesy Marcia Ravizza Lessley.)

THE LIVERY. Eugene J. Ravizza was born in Switzerland about 1890 and married Bertha Soderlund of Sweden. He is pictured in the livery that he owned with William Ludricks. (Courtesy Marcia Ravizza Lessley.)

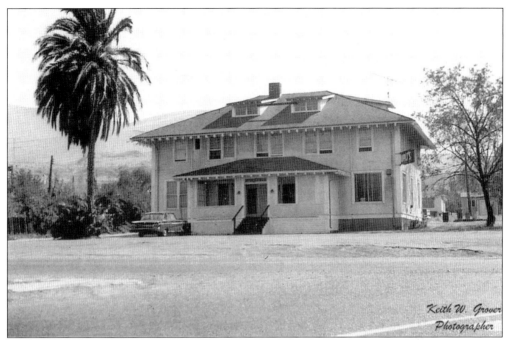

WALT'S INN. The Smith Lumber Company constructed this three-story building of many uses as a clubhouse in 1911. It served as Charles A. Smith's residence when he came to town and provided food and lodging accommodations for company officers and office staff. It also allowed for entertainments such as billiards and lawn tennis. Benjamin Grover and his wife ran the inn. When the lumber company left in 1932, its history becomes a little vague. Old-timers tell of Madame "Teddy" and her activities of ill repute here in the 1930s. The building later became a popular restaurant and bar. (Courtesy Keith Grover.)

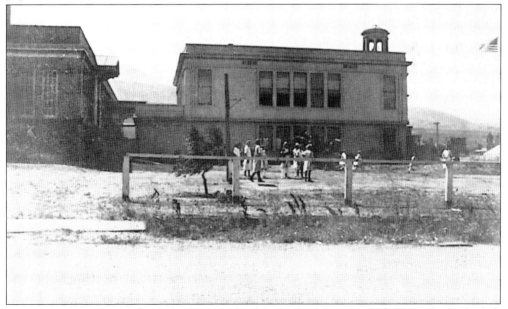

BAY POINT SCHOOL. In this early photograph of the back of the school, children play basketball at recess. (Courtesy Keith Grover.)

NICHOLS SCHOOL. Nichols, made up mostly of plant workers, had its own school. Seen here are members of the class of 1933 (above) and 1939 (below). (Courtesy Jerry Robbins Michaels.)

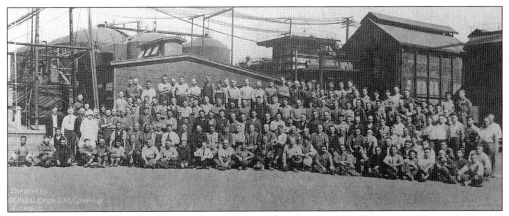

WORKERS OF GENERAL CHEMICAL. This photograph, taken on October 9, 1924, shows the entire workforce of the Nichols plant. As the longest-running industrial plant within modern Bay Point boundaries, it is approaching its 98th anniversary. (Courtesy General Chemical Company, Bay Point.)

FOUR SODERLUND SISTERS. Seen here around 1925 are, from left to right, Beda, Eugene Ravizza, Bertha, Lyda, and Evelyn. (Courtesy Marcia Ravizza Lessley.)

SUNDAY GATHERING. This unidentified group assembles at the Bay Point School, which served as a center of the community. Its roots went back to 1857, and its teachers educated six generations of children. (Courtesy Marcia Ravizza Lessley.)

Five

BY ANY NAME
THE GREAT DEPRESSION AND SURVIVAL

The third decade of the 20th century dawned favorably in Bay Point. Approximately 1,700 people lived in town. Although the stock market had crashed the previous October, the industries of several chemical plants, an oil refinery, a shipyard, and most importantly the Coos Bay Lumber Company were humming.

The New York stock market continued its slide through 1931 and 1932, with stock prices declining 89 percent from the peak in 1929. Walter S. Van Winkle and a few of his friends orchestrated a major public relations renewal of Bay Point, changing the name of the town to Chicago (suggested by F. G. Cox) as the first plank of a revitalization plan that included dredging a ship canal using Hastings Slough and grading, graveling, and rocking the roads of Bay Point. The dumping of Bay Point signs culminated in a death-and-birth pageant with fireworks, speeches, and a big dance. Mayors, industrialists, and representatives from around the bay attended the bash. The mayor of Chicago, Illinois, wrote in part, "Our city is deeply mindful of the distinguished compliment which you have conferred on us in making our city your godfather." Immediately afterward, pressure was put on the U.S. Postal Service to prevent use of the name, ultimately resulting in the town becoming *Port* Chicago.

The efforts of Van Winkle and the chamber of commerce were helpless against the national economic tide. By 1932, the Coos Bay Lumber Company had ceased operations in Port Chicago. Of the 250 families in town, 190 lost their jobs. Similar cutbacks in the largest industries decimated the town. For survival, many moved away. The small number who could stay married had children, sent them to school, and enjoyed the basics of community life. Later in the decade, Roosevelt's New Deal began to affect Port Chicago. The school was enlarged in 1936. Contra Costa Canal was built through the foothills above town in 1937. As the decade continued, the oil and chemical companies prospered by supplying their products to the Allied and Axis powers. Great Japanese MARU oil tankers pulled up to the docks at Associated Oil (Tosco–Golden Eagle) throughout the decade. There is good evidence that the Japanese fleet that bombed Pearl Harbor got its fuel oil from the MARUs that loaded up at Associated in mid-1941, despite a national oil embargo.

Who would have known?

SHARON LUTHERAN CHURCH AND EXPANDED SCHOOL. Built in 1918, the Lutheran church was mostly attended by the Scandinavians from Minnesota who worked at the lumber company. (Courtesy Keith Grover.)

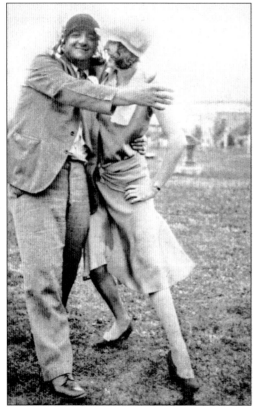

LOVING LIFE. Joe and Mary Flori "ham it up" during the roaring thirties in Port Chicago. In those days, the people of Port Chicago did not know they were living in the Great Depression. They just knew that many had lost their jobs and that times were hard. (Courtesy Marcia Ravizza Lessley.)

KEITH GROVER. Grover, shown here on his motorcycle, counted himself among the natives of Bay Point–Port Chicago. He worked at the steel mill in Pittsburg, raised his family in town, and was an accomplished photographer. As a former neighbor recalls, "He could fix anything." Grover took the cover photograph for this book. (Courtesy Keith Grover.)

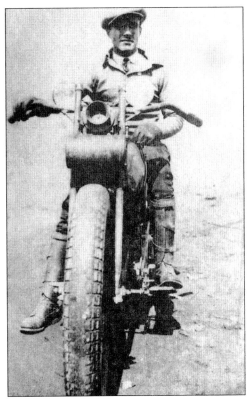

VAN WINKLE HOME. In addition to owning the water and power of the town, Walter and Eunice Van Winkle owned a general store and much of Clyde, including the hotel. Walter's brother William was a dentist. He lived in town for a while but then moved away. (Courtesy Keith Grover.)

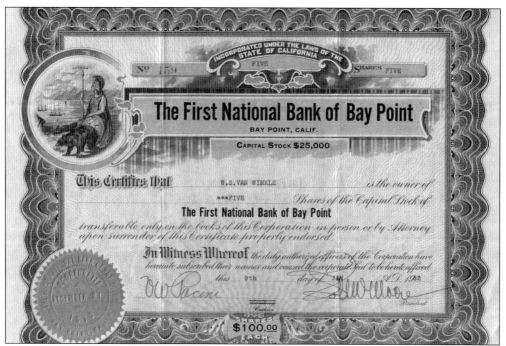

VAN WINKLE'S STOCK CERTIFICATE. Walter Van Winkle also owned interests in other local enterprises such as the First National Bank of Bay Point. One of his stock certificates is pictured here. (Courtesy Bay Point Historical Society.)

NAME CHANGE PARTY, JANUARY 26, 1931. Some 400 leading citizens of Contra Costa County attended a "birthday party" for the new town of Chicago at the Clyde Hotel. This day was also the birthday of ex-kaiser Wilhelm. (Courtesy *Contra Costa Gazette*.)

BAY POINT REVITALIZED, JANUARY 13, 1931. The Bay Point Chamber of Commerce outlined a seven-point, five-year plan for the revitalization of the town on January 13, 1931. Clara Bow was attending court that day in Los Angeles, hearing the confession of her secretary, who had embezzled $35,000 from the famous actress. (Courtesy *Contra Costa Gazette*.)

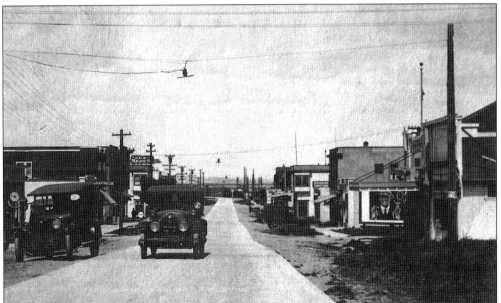

PAVED ROAD. Part of the renewal of the new town of Port Chicago was paving the main streets, an act that occurred in the early 1940s. Another great advancement was the arrival of natural gas pipelines. Because of this, mothers no longer had to get up at 4:00 a.m. to start wood-burning stoves for the preparation of breakfast. Young sons had generally been assigned to go down to the lumber yard and gather waste wood for the box that sat next to the stove. (Courtesy Keith Grover.)

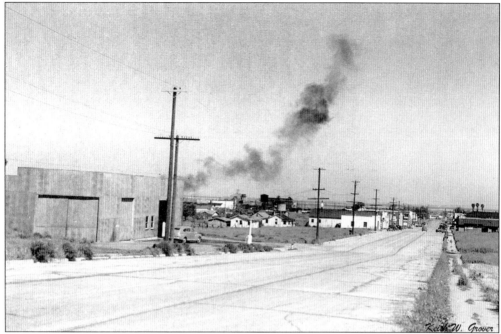

MAIN STREET. In this northward view, the building in the left foreground is the Mellor Beer distributorship. Owned by Frank Mellor, it was located near Division Street at the south end of town. (Courtesy Keith Grover.)

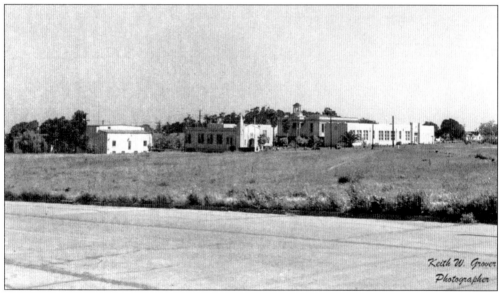

BAY POINT SCHOOL. The first Bay Point School was built in Pacheco in 1857. The second school was constructed on the site of Rio Vista Elementary School in 1868. Completed in the new town of Bay Point by May 1911, the third was a wood building with two rooms on the main floor and a basement elevated enough so the door leading to it was level with the ground. "It even had a bell tower on top, just like a typical old school house," recalled Woody Grover. This photograph shows the school after the large addition had been added. Arthur Donovan taught four generations of children there. (Courtesy Keith Grover.)

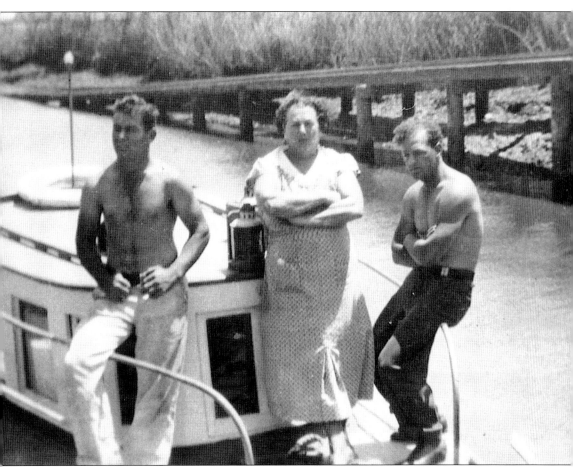

AT P. M. BELLOMO'S HARBOR. Africa Bertozzi (left), her son Tim (center), and Firpo Grossi are aboard the *Tanforan* in 1936. (Courtesy Harlan Bailey.)

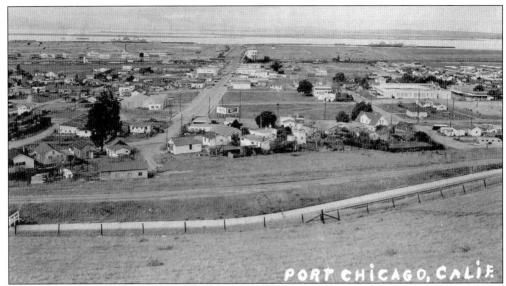

INDUSTRIAL PORT CHICAGO. Taken from the northwest, this view of the town shows the industrial section at the top, running along the railroad tracks. Also visible on the waterfront are the numerous dredges used to keep the channel clear. Next to the water tank and along the tracks, the Electro-Metals plant can be seen. The heavy slag heap created there was added to the material to build the road. To the upper right is a place the boys called "Bare Ass Beach" because the locals would sneak down and skinny dip on hot days. (Courtesy Keith Grover.)

BEALE HALL, 1941. This early Bay Point building may have remained from the old Smith Lumber Company buildings. Richard Beale, a Civil War–era native of Ohio, owned this hall. Before the Veterans Memorial Building was constructed, all the civic activities happened here. Beale lived in the house to the right. (Courtesy Keith Grover.)

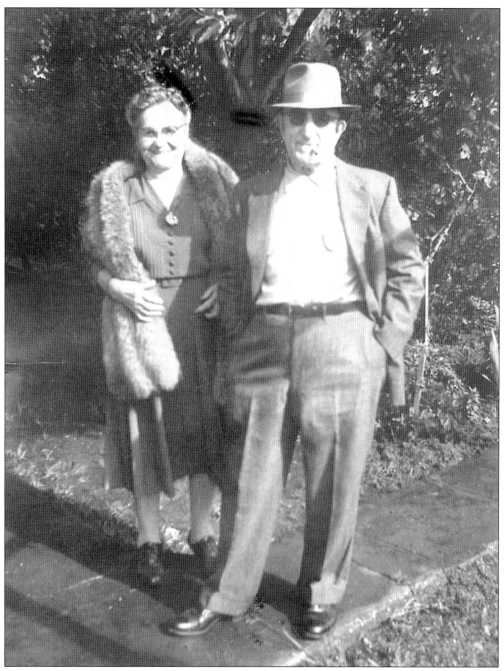

DOMENICO AND JULIA GROSSI. Posing under the fig tree, the couple prepares to watch the 1957 Easter parade. Nearly everyone in town would show up for these annual community parades. (Courtesy Harlan Bailey.)

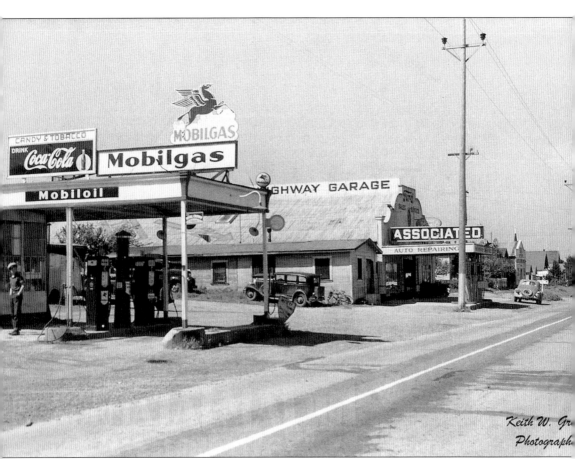

Mobil Service Station. Duke Nunes ran the Mobil station, pictured in the early 1940s. (Courtesy Keith Grover.)

Six

A Nation Mobilizes
A Community Grows

The surprise Japanese attack on Pearl Harbor was like a lightning bolt to the national economy. Though as a neutral country we had been supplying the combatants of both sides since 1939, suddenly it was all-out war. Like everyone else in the country, the young men of Port Chicago quickly enlisted.

All aspects of California economy went into industrial overdrive as the nation built the most powerful war machine in American history. The state's role was massive, with the Bay Area becoming a navy town as numerous military installations were built in the North, South, and East Bay. The need for munitions for the Pacific theater from 1942 to 1945 fell on several West Coast ports of embarkation. Just prior to the United States entry into the war, a crash building and acquisition program was begun in the 12th District. The rapidly expanding need for space led to the choice of Port Chicago as a prime munitions transshipment center. This effort was led by port director Milton R. Davis. The site of the Port Chicago magazine, though considered for 15 years prior, was given a major push under the recommendation of Davis to J. W. Greenslade, commandant of the 12th Naval District. "The great value of this site lies in its complete isolation from habitation and industrial activity," Davis stated.

Many war activities were placed in Contra Costa County. One of the largest army points of embarkation was built in Pittsburg. "Rosie the Riveter" became famous in the Kaiser shipyards of Richmond. Even the Byron Hot Springs did its part for the war effort, becoming a POW camp for German officers. The town of Moraga played a secret role. The wartime Moraga postmaster worked on Geiger counters for the Manhattan Project and ran a top-secret communications center out of his home. It is very likely that all Manhattan Project secret communications to California came though his house.

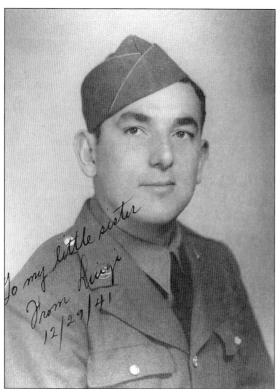

PORT CHICAGO VOLUNTEER. Luigi Grossi of Port Chicago sent this New Year's photograph to his sister on December 29, 1941—just three weeks after the country's engagement in the war. (Courtesy Harlan Bailey.)

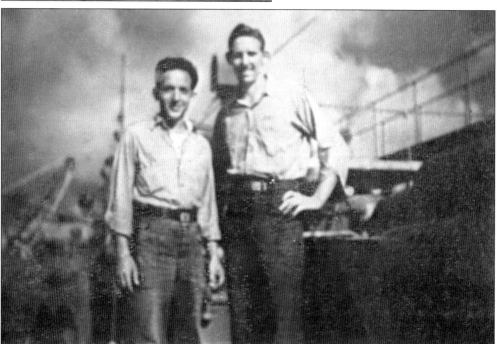

NAVY BUDDIES. Burt Ravizza (right) and a friend pose beside their ship during the war. Burt started working at Shell Chemical when he was 16 and joined the U.S. Navy at the Port Chicago American Legion Hall in 1943. (Courtesy Marcia Ravizza Lessley.)

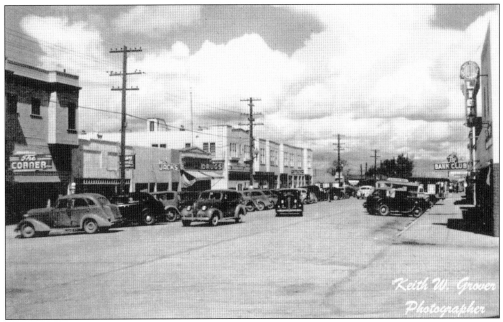

DOWNTOWN, LOOKING EAST. This photograph shows the downtown in a very busy period during World War II. (Courtesy Keith Grover.)

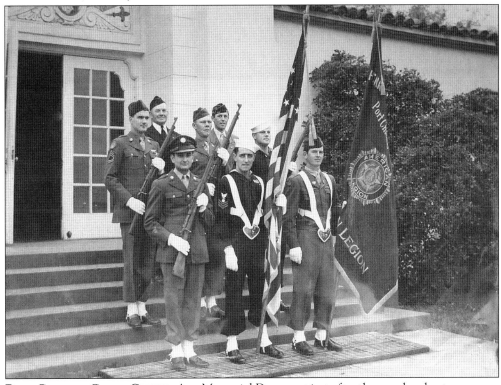

PORT CHICAGO COLOR GUARD. At a Memorial Day event just after the war, local veterans pose at Port Arms. Those identified are, from left to right, Harlan Bailey, ? Bessilever Sr., Les Ferguson, Nick Lagiss, George Green, Bob McMullen, and Nicholas Loges. (Courtesy Harlan Bailey.)

COUPLES PARTYING. Home on leave, Harlan Bailey Sr. (third from left) and his wife, Josephine (center), celebrate with two other couples. (Courtesy Harlan Bailey.)

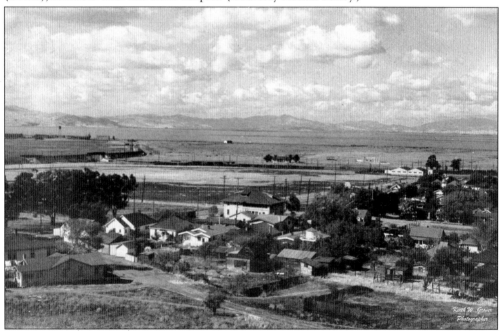

LOOKING NORTHWEST. This panoramic view reveals the waterfront, just prior to World War II and the coming of the U.S. Navy. In the upper left, the silent buildings of the former lumberyard sit idly. The industrial section, where the munitions would soon be loaded, lies fallow. In many ways, the war brought life to Port Chicago. Few, if any, opposed the military's presence. (Courtesy Sierra Pacific Region, National Archives.)

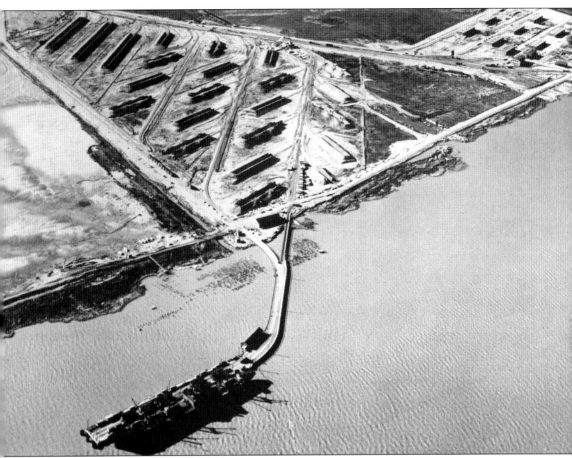

FEBRUARY 1944. A few months before the port would be forever changed, this aerial view shows the main loading pier jutting out from the warehouse section. (Courtesy Sierra Pacific Region, National Archives.)

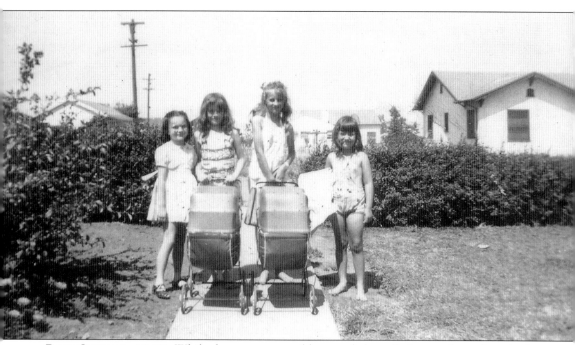

Port Chicago, 1940s. While the war years could not truly be called normal anywhere in the country, family life at Port Chicago went on as usual for the most part. Pictured here about 1943, from left to right, are Diana Bondi, Mary Ellen Regester, Connie Freeland, and Diane Freeland. (Courtesy Laura Regester.)

Seven

THE NEW AGE
AN EXPLOSION ROCKS PORT CHICAGO

On July 17, 1944, at 10:20 p.m., the main dock at Port Chicago blew up. Two ships, one nearly loaded and the other empty, exploded a few seconds apart. The SS *Quinalt Victory* was entirely dismembered and blown some 500 yards. The SS *E. A. Bryan* was completely vaporized. The blast caused a crater 66 feet deep, 300 feet wide, and 700 feet long in the river bottom. The explosion killed 320 men instantly and wounded over 400 in the largest home front disaster of World War II. Nearly every home and business in Port Chicago was damaged, but fortunately no one in the town was killed.

Pilots of two Army Air Corps planes happened to be above the town at the precise time of the blast. Says Peter Vogel, "At different altitudes the planes were oriented line-of-sight toward the explosion at the moment of the explosion. Their presence was either a fortuitous coincidence or was planned to be coincident with the explosion. If the latter, the time of the explosion would have to have been precisely anticipated, and the pilots' flight plans accordingly instructed." Over the next days, many special observers arrived on the scene. These visitors were high-ranking individuals heading up port-busting research; developing high-speed photographic equipment needed to record the performance of weapons and materials; studying the use of U.S. Navy divers to sabotage shore defensive positions; and working on the Manhattan Project. They included the following: Capt. J. C. Byrnes, chief of the Bureau of Ordnance; Col. Crosby Field and Lt. Col. Ruel Stratton of the Safety and Security Branch of the War Department; Capt. Radford Moses, Comdr. J. H. Sides, and Capt. "Deke" Parsons (who armed the Hiroshima bomb aboard the *Enola Gay*); Col. F. H. Miles of the Bureau of Ordnance; D. Max Beard and E. Moss Brown, civilian employees of the Naval Ordnance Laboratory; and Prof. John F. Burchard, chairman of the Demolition of Obstacles to Landing Operations Committee (DOLOC) of the Office of Scientific Research and Development.

The official reports of the explosion, consisting of comprehensive analyses of the blast damage, were prepared at Los Alamos and reviewed by the top men of the Manhattan Project (Brig. Gen. Leslie Groves, Rear Adm. William R. Purnell, Vannevar Bush, and James Conant). Was this an accidental explosion, or was it a test of an experimental port-busting weapon under study by the Manhattan Project?

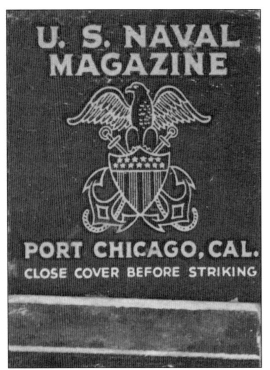

MATCHBOOK. This is one of the most memorable images of Port Chicago. Provided to local U.S. Navy personnel during World War II, matches were a reminder that every time a sailor, stevedore, or officer lit up, safety was paramount. Safety standards were radically altered after the explosion. For the first time, a safety manual was prepared and actual training was given to officers and munitions handlers. Inspections began on a regular basis. (Courtesy Bay Point Historical Society.)

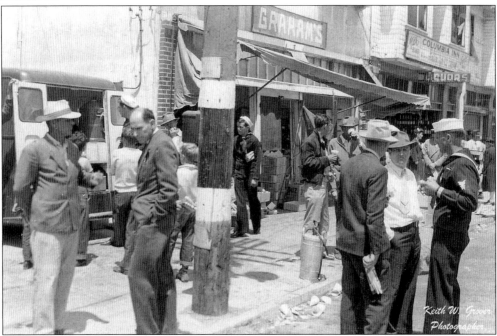

THREE DAYS LATER. Relief efforts the night of the explosion and the following days were extraordinary. Among the civilian respondents were fire departments from Martinez, Mount Diablo, Rio Vista, Crockett, Berkeley, and Associated Oil at Avon. Others who showed up were the Red Cross, USO, and Salvation Army. Many of the Port Chicago residents with boats assisted in the search for bodies in the bay over the next few days. (Courtesy Keith Grover.)

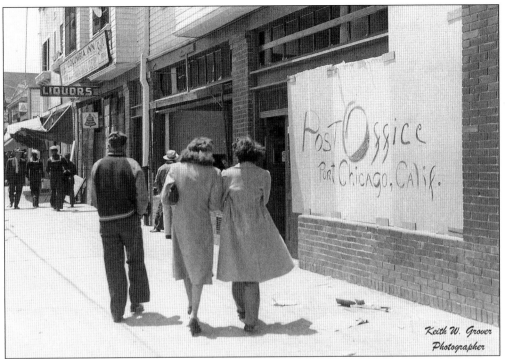

POST OFFICE IN BUSINESS. Within 48 hours, postmaster George German resumed mail operations. He put up temporary wallboard and hand painted the sign shown here. The explosion ripped water mains at the munitions depot, draining 3 million gallons of water from the reservoir in the hills. Water pressure was restored within two days. (Courtesy Keith Grover.)

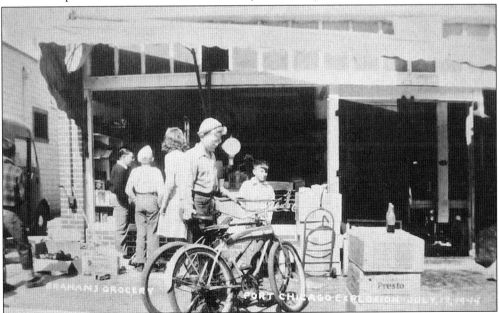

CHECKING OUT THE DAMAGE. This photograph catches the action as cleanup began at Graham's Grocery on Main Street. Notice the Coke bottle on the right. (Courtesy Marcia Ravizza Lessley.)

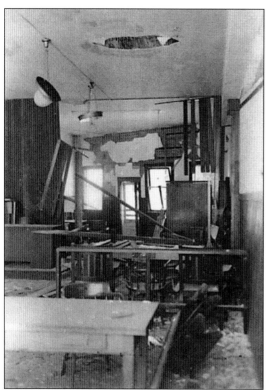

COURT DAMAGE. Judge Lichti's justice court office was one of the more seriously damaged buildings in town. In Port Chicago, all misdemeanors were judged locally. In California, these jurisdictions were later called municipal courts. (Courtesy Keith Grover.)

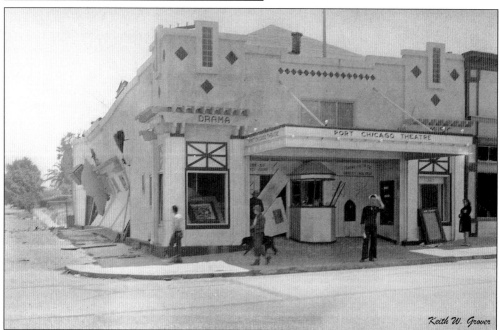

JOE MEYER'S MOVIE THEATER, JULY 18, 1944. The night of July 17, about 195 Port Chicagoans and U.S. Navy personnel watched the movie *China* starring Alan Ladd, Loretta Young, and William Bendix. While a film of the bombing of Burma was blasting inside, the world outside was also exploding. No one inside noticed. (Courtesy Keith Grover.)

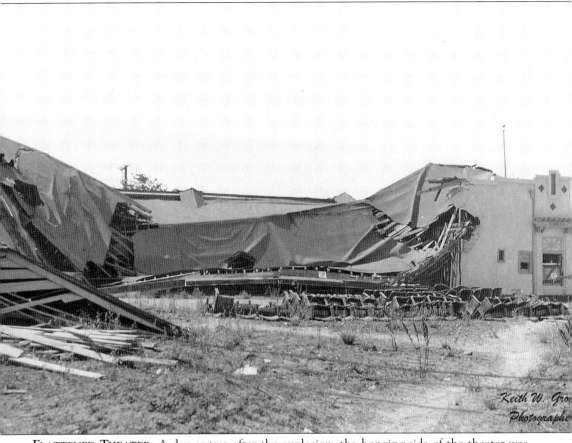

FLATTENED THEATER. A day or two after the explosion, the hanging side of the theater was knocked down for safety reasons. Occasionally, this photograph is used to show the original damage, but this result was, in fact, achieved after partial demolition. (Courtesy Keith Grover.)

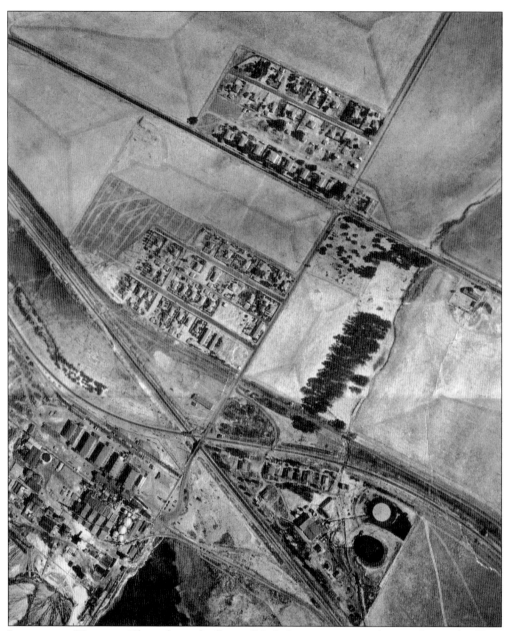

INDUSTRIAL NICHOLS. The industrial village of Nichols was constructed two miles south of Port Chicago. Heavy industrial plants seen at the bottom of this photograph were built after 1910. Housing for the workers was built soon after, as seen in the top half of the photograph. The area on the right with trees and shrubs was the site of the Nichols School. Students eventually were transferred to the Bay Point School in Port Chicago.

VETERANS MEMORIAL BUILDING. This building was one of the largest in town. Many volunteers were posted to its roof as air-raid wardens during World War II. It served as the headquarters for many community activities, including planning, first aid, and Red Cross activities after the explosion. (Courtesy Sierra Pacific Region, National Archives.)

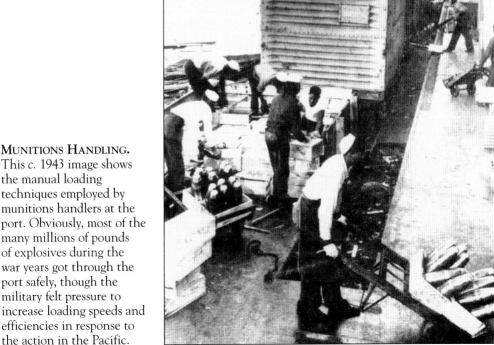

MUNITIONS HANDLING. This c. 1943 image shows the manual loading techniques employed by munitions handlers at the port. Obviously, most of the many millions of pounds of explosives during the war years got through the port safely, though the military felt pressure to increase loading speeds and efficiencies in response to the action in the Pacific.

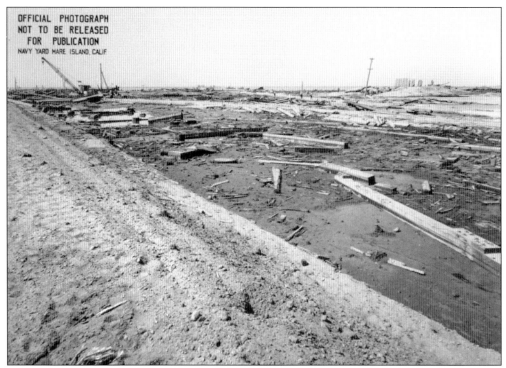

DAMAGED PIERS. The explosion completely destroyed the loading piers in addition to the ships and equipment that were decimated. (Courtesy Sierra Pacific Region, National Archives.)

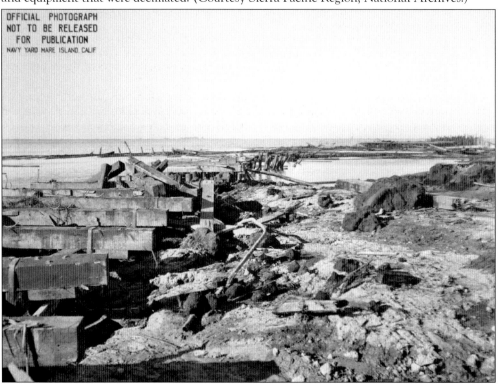

Eight

PORT CHICAGO
A NUCLEAR HISTORY

All over the Bay Area, military facilities blossomed for the war effort. Over the hills in Berkeley, the biggest of these plans was being made. The Manhattan Project, the code name for the project to make the atomic bomb, obtained from Berkeley some of its key talent in harnessing this world-changing power. One author wrote, "After Fermi's breakthrough on fission, all possible avenues of research were simultaneously funded and pushed. Facilities all over the country were brough on line to perfect the bomb. The entire length and breadth of the United States became a secret, humming, sometimes roaring bomb research and development facility." Port Chicago was just such a principal facility beginning in 1944.

President Roosevelt appointed Vannevar Bush to head up the top-secret development of the bomb and created the Office of Scientific Research and Development, consisting primarily of civilian scientists. Capt. William S. Parsons managed the ordnance division of the Manhattan Project laboratories at Los Alamos, New Mexico.

As invasion landings were considered so costly in lives, a concurrent effort occurred to prepare remote-control mine-clearing technologies for the land invasion of Europe. John Burchard headed DOLOC in Washington, D.C., and Fort Pierce, Florida. Its objectives were to address technologies that, according to Lincoln R. Thiesmeyer and John Burchard in *Combat Scientists* (Little, Brown, and Company, 1947), "would accomplish demolition from a distance, methods of placing charges by stealth, say a week ahead and safety fuses that would work under water. They were also tasked with designing a transportation unit to bring demolition crews to the obstacle area and a container for 100 pounds of explosives that could be towed by a swimmer."

The last nine months of DOLOC's history have not been brought to light. Was this project intended to provide an alternative delivery system for the atomic bomb? The 1944 activities of committee members suggest a direct link to Parsons's activities at Los Alamos and to Port Chicago. For perspective, consider this: The most difficult job of senior officers in wartime has always been to weigh the costs in men and material of a particular battle action or strategy against an overarching plan. The connections between DOLOC, the Manhattan Project, and Port Chicago, while not definitively clear, are extraordinary. Could the explosion, which literally vaporized an entire ship and broke windows 40 miles away, have occurred from standard World War II munitions, by accident?

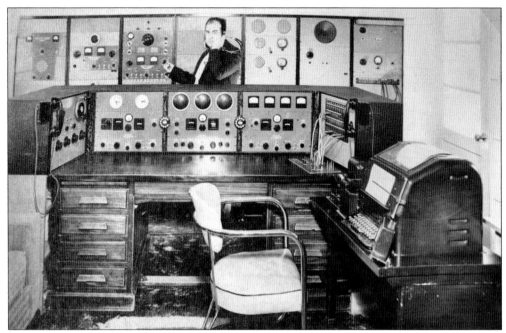

POSTMASTER TIBBETTS. The University of California at Berkeley was a central scientific resource for the war, particularly for the Manhattan Project. Contra Costa County played a pivotal role in covert activities. D. Reginald Tibbetts was appointed postmaster of Moraga while secretly working on the Geiger counters used in the development of the atomic bomb. His cover as postmaster was to protect classified military apparatus shipped by U.S. Mail in locked containers. He is shown here in one of his "bedrooms" with his communications equipment. (Courtesy John Garvey.)

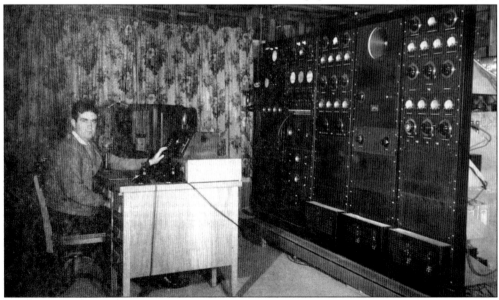

TIBBETTS COMMUNICATIONS CENTER. The other Manhattan Project top-secret communication centers were located at Oakridge, Tennessee; Chicago, Illinois; Richland, Washington; and Los Alamos, New Mexico. Top-secret communications from Port Chicago may have gone through Moraga as well. (Courtesy John Garvey.)

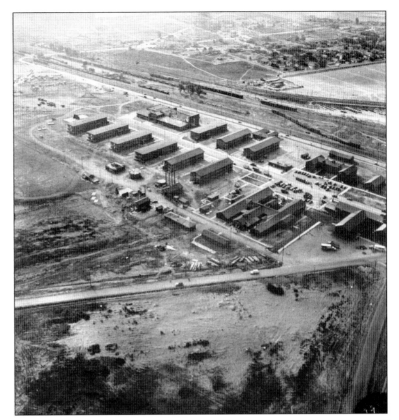

CONSTANT RAIL TRAFFIC. This c. 1946 aerial view depicts the heavy rail traffic in and around the port's warehouse district. During the war years, rail traffic occurred around the clock, in order to supply Pacific theater operations. (Courtesy Sierra Pacific Region, National Archives.)

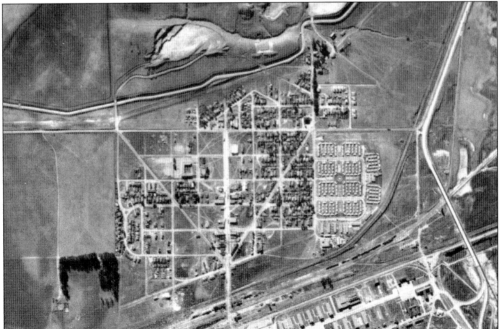

AN UNEASY TRUCE. The proximity of the residential and industrial-military sections of the town can clearly be seen in this 1945 image. (Courtesy Sierra Pacific Region, National Archives.)

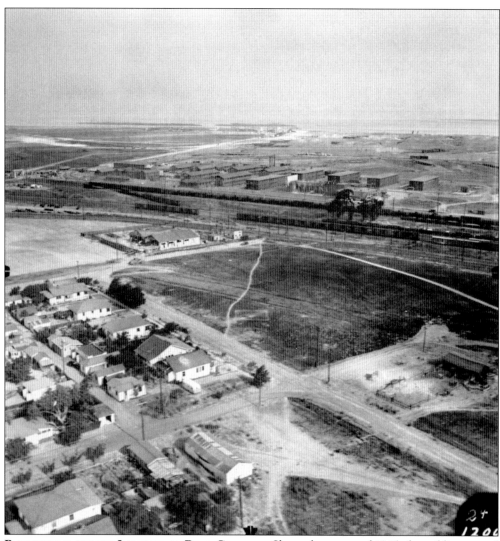

RESIDENTIAL VERSUS INDUSTRIAL PORT CHICAGO. Shown here around 1945, the rail line served as a divider of sorts between the housing and industrial segments of the port. Later events would prove this arrangement insufficient, as far as the U.S. Navy was concerned. (Courtesy Sierra Pacific Region, National Archives.)

WILLIAM "DEKE" PARSONS. Captain Parsons was the Manhattan Project's chief ordnance officer, one of four division heads working directly under General Groves. In a practical sense, the bomb was an ordnance problem entrusted to Parsons. He and his associates were immediately on the scene after the Port Chicago explosion. Parsons also served as head of Project Alberta, which oversaw the delivery of the bomb. In July 1945, he assembled "Little Boy" at Los Alamos and then reassembled it on the island of Tinian in the Marianas immediately prior to its loading on the *Enola Gay* for the flight to Hiroshima. (Courtesy Navy Yard, Washington, D.C.)

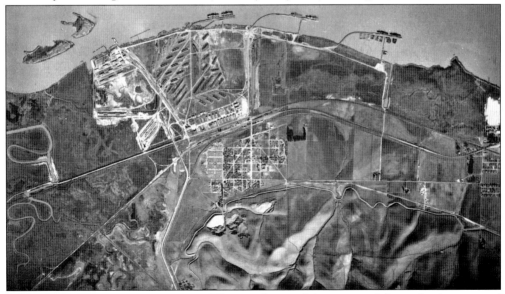

PORT CHICAGO, DECEMBER 12, 1948. This aerial view of the town and the wetlands portion of the Concord Naval Weapons Station reveals the proximity of the town to the munitions storage area. Events would prove that there was not enough room for both the town and the U.S. Navy. (Courtesy Marcus O'Connell.)

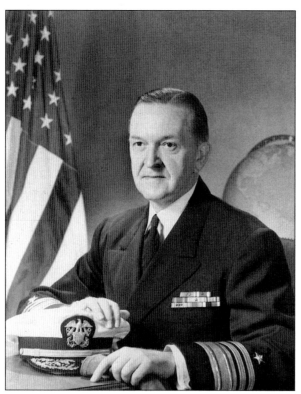

COMDR. J. H. SIDES. A 1925 graduate of the Naval Academy, Commander Sides was among the Bureau of Ordnance officers who flew to Port Chicago on July 18, 1944. In 1942, he had been made chief of the ammunition and explosive section of the bureau. His precise role at Port Chicago is unclear, but within weeks of the explosion a letter and a memo from Conant to General Groves noted that "we have had the first positive indications as far as our main program goes. . . . Mark II can be developed for combat use in 3 or 4 months time." This photograph shows Commander Sides in later years as vice admiral. (Courtesy Navy Yard, Washington, D.C.)

"**COMINCH**" **REQUESTS, JULY 22, 1944.** The commanding officer at Port Chicago received this authorization for Max Beard and Moss Brown to do their work after the explosion. "Cominch" was Admiral King, commander-in-chief of the American fleet. Parsons, who was responsible for the ordnance issues of the Manhattan Project, also reported to Admiral King. (Courtesy Sierra Pacific Region, National Archives.)

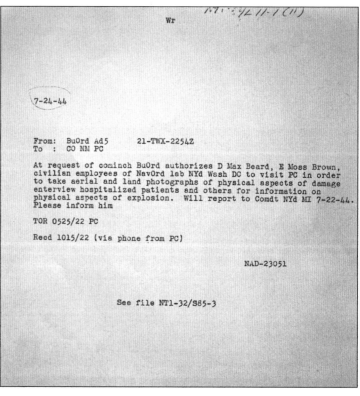

HIGHLY CLASSIFIED AND URGENT PROJECT, AUGUST 18, 1944. Following the reports of Beard and Moss, the Naval Ordnance Lab in Washington wrote to the commandant at Mare Island thanking him. The entire "highly classified and urgent" project was materially advanced by the assistance of the officers at Mare Island and Port Chicago. (Courtesy Sierra Pacific Region, National Archives.)

BROKEN GLASS. This photograph of the blast damage shows the entire range of the explosion. Note that windows were blown out from Vacaville, Petaluma, and Rio Vista on the north to Belmont on the south and Brentwood on the east. The inside line charts structural damage in a wide swath of portions of Contra Costa and Solano Counties. Language describing the scope of damage at Port Chicago was precisely parallel to the description of the expected damage of the "10,000 ton gadget" passed out to incoming scientists at Los Alamos. (Adapted from Court of Inquiry, Exhibit No. 2736; courtesy Sierra Pacific Region, National Archives.)

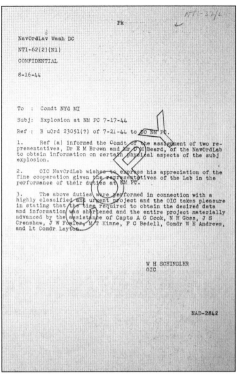

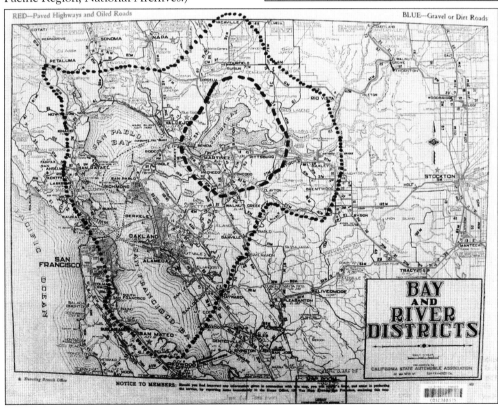

WOODY GROVER. The U.S. Navy collected and carefully inventoried every piece of shrapnel that fell on Port Chicago and the surrounding area. Personnel scoured the entire military complex and every inch of the town, though a certain amount of leakage existed in their collection program. Nearly everybody in town collected ship shrapnel as a physical reminder of that night. Much material never found its way to the authorities. Some, like Woody Grover, used their wagons for maximum efficiency. (Courtesy Keith Grover.)

REMAINS OF SS E. A. BRYAN. Untrained white officers and black stevedores competed that July 1944 to see which unit could load the most munitions. Survivor Joseph Small was frequently told, "If it explodes, you won't know anything about it." "Since there were no detonators in any of the shells or bombs, it was impossible for them to go off" (*The Good War* by Studs Terkel). As the image makes obvious, there were no remains. (Courtesy Sierra Pacific Region, National Archives.)

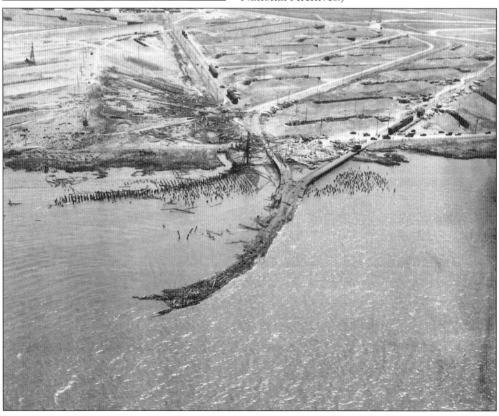

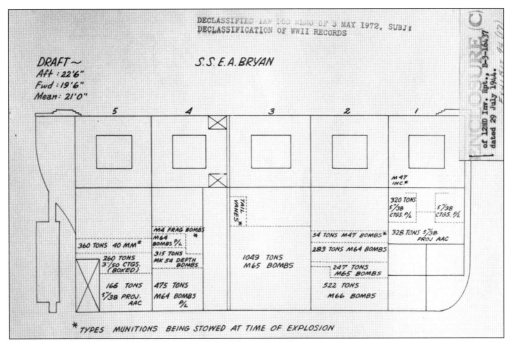

BOMBS ABOARD SS *E. A. BRYAN*. This diagram shows how munitions were stored in the ship, which was completely destroyed in the explosion. (Courtesy Sierra Pacific Region, National Archives.)

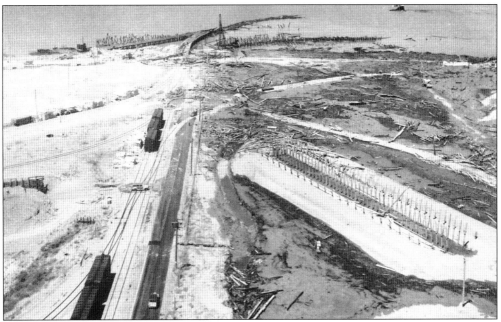

CENTER OF DESTRUCTION. The explosion killed 322 men and injured 490. Authorities recovered 80 bodies, only 30 of which were identified. The station had been manned by almost 100 percent black enlisted loaders prior to the explosion. "They had no prior training whatsoever and but a 'once over lightly' indoctrination in military conduct and bearing at the naval training station, Great Lakes" (*The Good War* by Studs Terkel). (Courtesy Sierra Pacific Region, National Archives.)

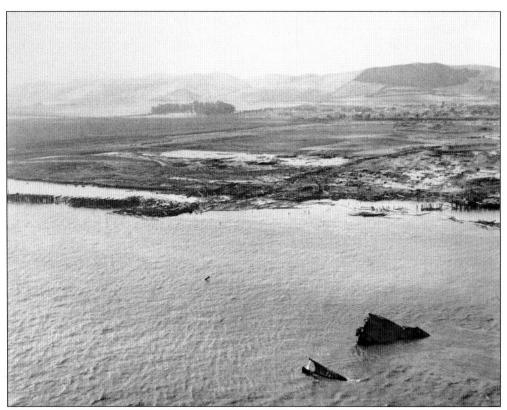

QUINALT VICTORY'S WATERY GRAVE. The stern, propeller, and a portion of the main section of the SS *Quinalt Victory* lie in the murky water after the explosion, making for an eerie sight both from the sky (above, including the surrounding devastated loading area) and the water (below). (Courtesy Sierra Pacific Region, National Archives.)

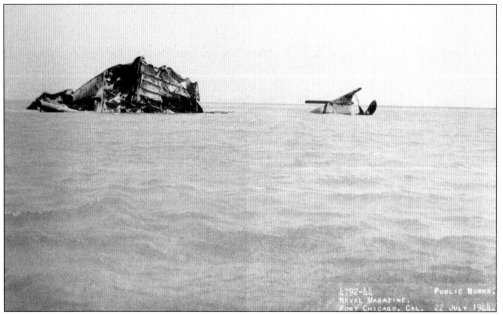

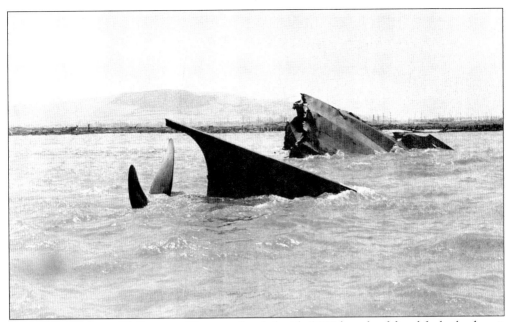

STERN REMAINS OF SS QUINALT VICTORY. Loaded with 5,300 barrels of diesel fuel oil, when it exploded, the 427-foot ship "was lifted from the water and broken in half, the stern twisted two hundred feet in the air and turned completely around, crashing into the channel upside down [one thousand feet] away from its mooring site" (*The Good War* by Studs Terkel). "Sixty-five feet of the keel remained." (Courtesy Sierra Pacific Region, National Archives.)

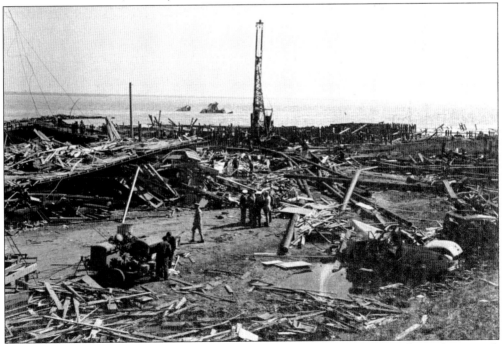

CLEANUP BEGINS. Workers, surrounded by debris and equipment, begin the arduous cleanup task after the explosion. The *Quinalt Victory*'s remains appear in the background. (Courtesy Sierra Pacific Region, National Archives.)

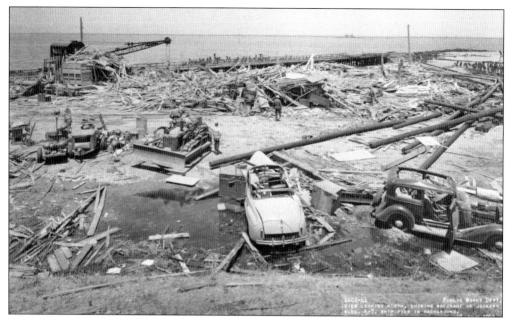

REMAINS OF THE PIER. This northward view shows the wreckage of the joinery building and the remains of the main pier. (Courtesy Sierra Pacific Region, National Archives.)

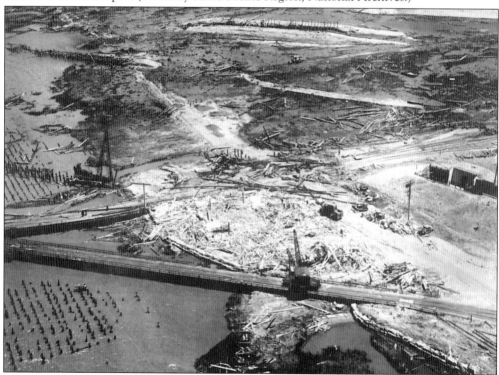

DIGGING OUT AT THE MAGAZINE. Men are dwarfed by cranes as they work to remove debris. Two magazine enlisted men and Port Chicagoans James Henry Born and Elmer Bertie Froid died in the explosion. Born was a 39-year-old native of Wagon Wheel Gap, Colorado. (Courtesy Sierra Pacific Region, National Archives.)

THE BARRACKS. The next day or so after the explosion, the work of loading munitions continued. The main barracks are shown above; below, the full complement of the magazine lines up for chow. (Courtesy Sierra Pacific Region, National Archives.)

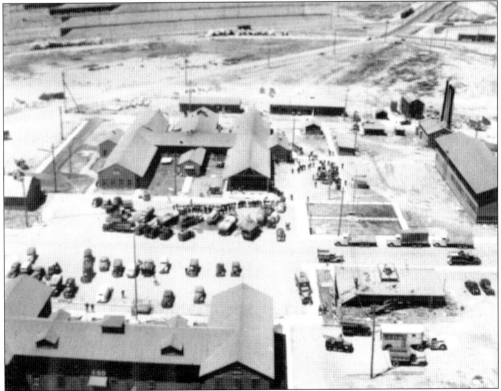

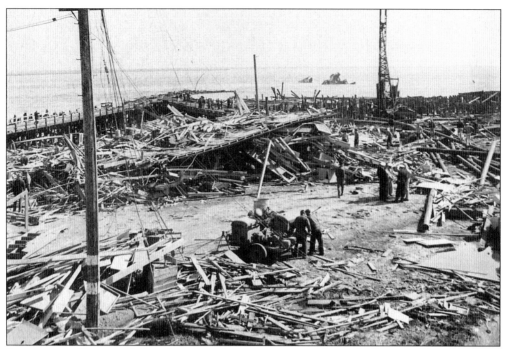

SIFTING THE RUBBLE. Enlisted men, civilian repairmen, and naval officers in blue and khaki start the work of cleanup. Almost miraculously, the magazine operations were functional within two weeks. (Courtesy Sierra Pacific Region, National Archives.)

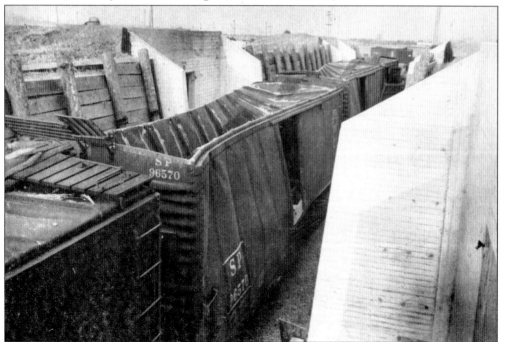

BENT BOXCARS. The force of the explosion was sufficient to crumple these railroad boxcars in the vicinity. No one will ever know if any hoboes were aboard. (Courtesy Sierra Pacific Region, National Archives.)

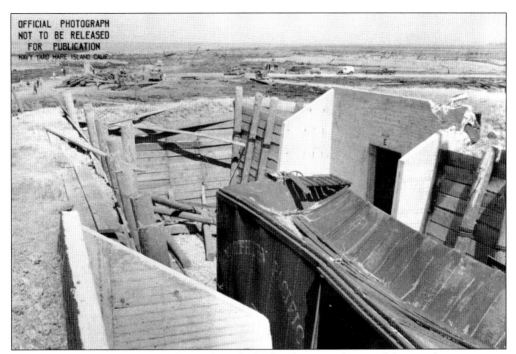

MORE BOXCAR DAMAGE. That the tough steel of railroad cars was bent and destroyed is a testament to the force of the blast. The fact also lends credence to reports of windows shattered as far away as San Francisco and San Mateo. (Courtesy Sierra Pacific Region, National Archives.)

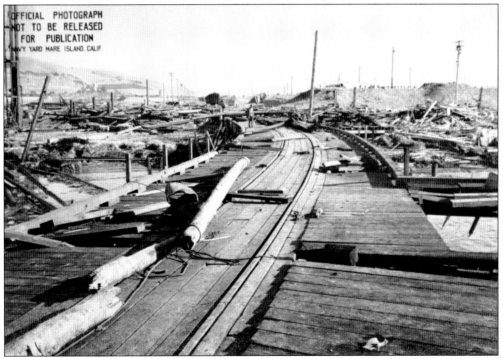

RAILS OF DESTRUCTION. This view, looking south from the site of the explosion, shows the extent of the damage along the rail line. (Courtesy Sierra Pacific Region, National Archives.)

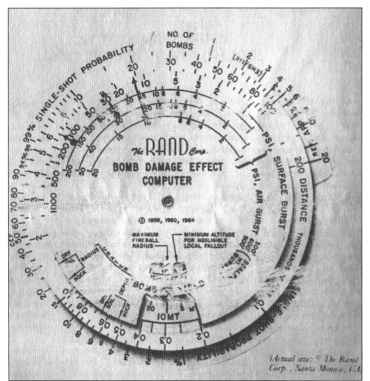

MEASURING ARMAGEDDON. The mathematics and physics of nuclear explosions engaged the best minds of the country during the second half of the 20th century. This memento of the Cold War appeared on the cover of *California* magazine in June 1985 as a reminder of the possible consequences of nuclear war. Although certain confirmation is some distance away, there is independent evidence of a low-level radioactive plume to the northeast of Port Chicago to this day. (Courtesy Sierra Pacific Region, National Archives.)

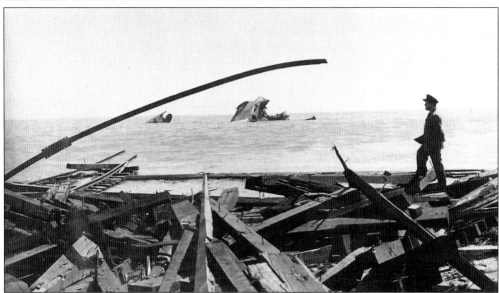

OFFICER SURMISES. This unidentified officer, likely from the 12th Naval District, stands at a historic spot now shrouded in obscurity. What really happened here? If it was simply a wartime accident caused by untrained white officers putting unsafe production pressure on uneducated black sailors, that is one story. If the explosion was an accident or test involving a small-yield predecessor of the bombs that exploded at Hiroshima and Nagasaki, it becomes something entirely different. Plenty of circumstantial evidence suggests the latter, though definitive proof is lacking. (Courtesy Sierra Pacific Region, National Archives.)

Nine

THE 15-YEAR SIEGE
WON HEARTS AND PACIFIED MINDS

Despite, or as a consequence of, the explosion on July 17, 1944, a new age began that eventually determined the fate of the town of Port Chicago. By August of that year, after studying the explosion (a proof test of the Mark II device), the Manhattan Project went into full engineering mode to develop the final combat atomic weapons, which were battle-ready by 1945. Those who appeared at Port Chicago within days of the blast played key roles in the final delivery of the bombs to Japan.

Peter Vogel, quoting Russ Harlow in *Project Alberta*, provides information about Port Chicago's part in the actual delivery of the atomic bomb:

> The fissionable projectile of the Hiroshima (Mark I, Little Boy U-235 gun assembly) weapon arrived at Port Chicago in a specially guarded rail shipment and was lightered down the river through Carquinez Strait to San Francisco Bay, to Hunter's Point Naval Shipyard, loaded and secured to the deck of the cruiser USS *Indianapolis*. The fissionable target rings of the weapon were air shipped by C-54: Los Alamos–San Francisco–Hawaii–Tinian. The gun barrel/tube and its ballistic case were also shipped, in one separate shipment, by air.

The bomb was then delivered to Hiroshima, armed in the air by Captain Parsons.

This changed everything in Port Chicago's world. Along with all the other weaponry developed for subsequent wars, Port Chicago became the parking place and shipment center for nuclear bombs. As nuclear missile systems were developed in the 1950s, the need for tighter security at Port Chicago became necessarily extreme.

There was no way for the military to openly explain to the residents of Port Chicago why their town must yield to the base's need for more room without broadcasting to all possible enemies of the growth of this strategic nuclear facility. It was necessary to argue a plausible safety issue, based on the need for a buffer zone in light of the World War II explosion. Off and on for 15 years, the U.S. Navy performed specious "studies" and worked behind the scenes to prevent the growth of industry in and around the town. At the same time, it worked through regional chambers of commerce and City of Concord centers of influence to dismiss the objections of the townspeople. The media, including national newspapers, had a field day with the David and Goliath story of Port Chicago and the U.S. Navy. While this public affairs battle grew from a barely perceptible peep in 1952 to a roaring crescendo in 1968, the people of Port Chicago lived their lives.

A Future in Port Chicago? Looking down on Port Chicago the year of the explosion, Harlan and Jo Bailey consider their future. Harlan was home on military leave. Jo was pregnant. Her son would go on to serve in the Vietnam War and return to a town confiscated by the U.S. Navy. (Courtesy Harlan Bailey.)

They Learned to "Duck and Cover." In the flexible way of fourth graders everywhere in 1955, Mrs. Bates's class learned more than the "Three Rs." What they were not taught, though, was that their school was in the center of the bull's-eye of one of the top 10 nuclear targets on the Pacific Coast. Under the guise of protecting these children from a World War II munitions explosion, U.S. Navy strategists began to take steps that year to remove not only the school, but the town from the center of the bull's-eye.

THINK OF THE CHILDREN. Second graders from Miss Larsen's class seem normal and happy in their industrial and military surroundings in 1953. (Courtesy Marcia Ravizza Lessley.)

ANOTHER WARTIME FAMILY. As in all small towns during World War II, families gathered for photographs when their sailor or soldier arrived home on leave. This unidentified family represents many in Port Chicago. (Courtesy Marcia Ravizza Lessley.)

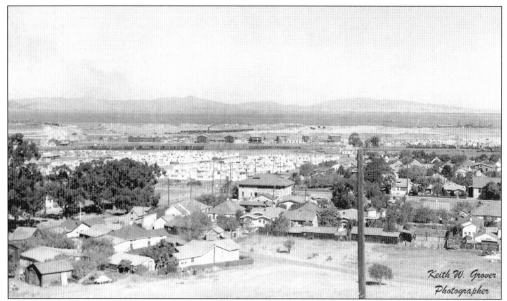

WEST SIDE OF PORT CHICAGO. The government housing development Knox Park, the naval barracks, the docks, and Suisun Bay are seen in the 1950s. The two-story building in the center was originally a hotel run by Benjamin and Elnora Grover, later called Walt's Place. In a closed House of Representative Armed Services Committee hearing in Port Chicago attended by George R. Miller, John Baldwin, and others, Rear Adm. F. I. Entwistle stated that 76 percent of all munitions for the Korean War came through Port Chicago. (Courtesy Keith Grover.)

BAY POINT SCHOOL, 1947. The eighth-grade graduating class poses with principal Kermit Allen (far right). Most of the children were bound for Mount Diablo High School in Concord. (Courtesy Marcia Ravizza Lessley.)

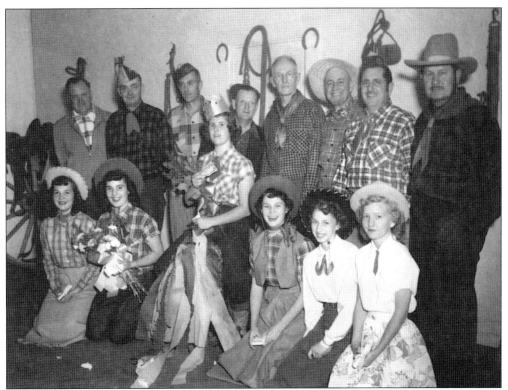

WESTERN PARTY. This party was one of many youth activities frequently held. These young people and town elders were just plain folks, the stuff of small-town America in the mid-1900s. (Courtesy Marcia Ravizza Lessley.)

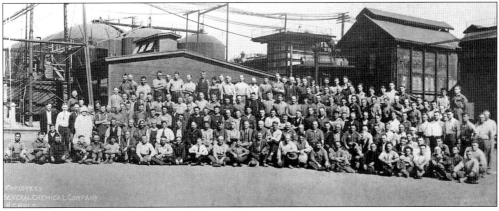

GENERAL CHEMICAL PLANT. The heavy industrial plant shown here, built in 1910, is deeply rooted in the community. This representative group photograph, taken in 1924, could have been taken even today, as the facility continues to produce basic chemicals for a world market. (Courtesy General Chemical Company, Bay Point.)

EASTER PARADE, 1948. Every year, the town celebrated Easter with a parade. It did not compare to the media events that parades now create, but it was a chance for all the young people and their families to dress up, be seen, and celebrate the coming of spring, redemption, and the Easter Bunny. (Courtesy Keith Grover.)

DOMENICO AND JULIA GROSSI. A pipe-smoking Domenico seems happy in his shirt sleeves, while Julia wears a warm coat for a stroll in town. (Courtesy Harlan Bailey.)

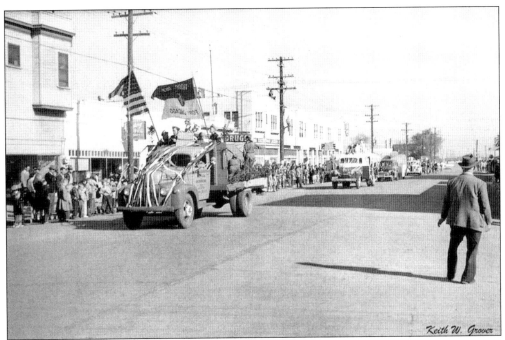

FOURTH OF JULY PARADE. The entire town showed up for each year's Independence Day parade. This particular photograph shows the parade being led by Port Chicago Troop 187 of the Boy Scouts. (Courtesy Keith Grover.)

BOXERS, 1949. Firpo Grossi (left) and a buddy do what boys did "back in the day." (Courtesy Harlan Bailey.)

POSTWAR SODERLUNDS. Many of the original settlers moved to Modesto to take up farming when the lumber company shut down in 1932. Shown in Modesto, from left to right, are the following: (first row) Burt Ravizza, Katherine, Henry, and Jenette; (second row) Grandpa Andrew Olaf, Lida, Emma Marie Lind, Ed, Helen, Emily (Burt's wife), and Grandma Bertha. (Courtesy Marcia Ravizza Lessley.)

FLYING A SERVICE STATION. One of several stations in town, the Flying A was owned by Larry Reese. The car, a 1931 Model A Ford, was owned first by Keith Grover, then by his son Woody, who said, "It's a good thing the old Model A can't talk, or it might tell a few good tales." (Courtesy Keith Grover.)

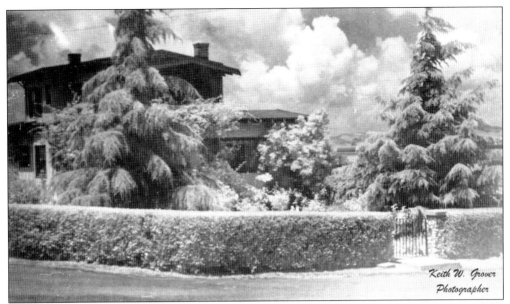

KEITH GROVER HOME. This home, located at 329 Poplar, served as the gathering place of the Grover clan and their friends. The family owned the residence from 1933 to 1968. Heavily damaged in the explosion of 1944, it was the site of Woody Grover and Johnny Woods's occasional escapades. (Courtesy Keith Grover.)

PORT CHICAGO LIBRARY. Consisting of 113 volumes, the first book collection was kept in the first-aid room of the Smith Lumber Company. Mrs. Claxton White was appointed the first custodian in 1916 and held the job for nearly 40 years. In 1918, the Bay Point Women's Club provided the pictured library, which consisted of 210 square feet. By 1963, new quarters had been found at the Veterans Memorial Building. The final librarian was Louise Grover, who locked the doors in September 1968 after serving for 14 years. (Courtesy Marcia Ravizza Lessley.)

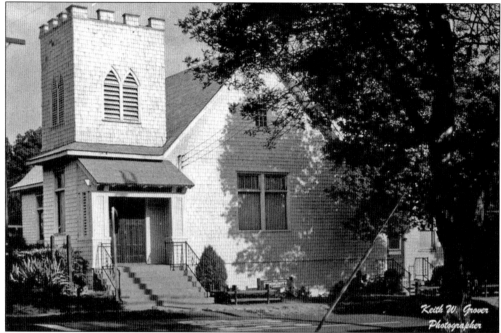

COMMUNITY CONGREGATIONAL CHURCH. Among those who attended the Congregational church were members of the Van Winkle, Gross, Grover, Lazzarini, Besselievre, Noyce, Brooks, Morton, Ward, and Woods families, among many others. Sherwood Wirt, an early minister here, later worked for Billy Graham. Founded in 1908, the church was rededicated by Rev. N. F. Sanderson in February 1945 after being badly damaged in the 1944 explosion. (Courtesy Keith Grover.)

BAY POINT SCHOOL. This photograph of Bay Point School was taken from Hayden and Central Avenue. Pictured are the new additions built during the 1950s, when the U.S. Navy began its public relations efforts to hurt the town by reporting on the backwardness and decline of the community. (Courtesy Keith Grover.)

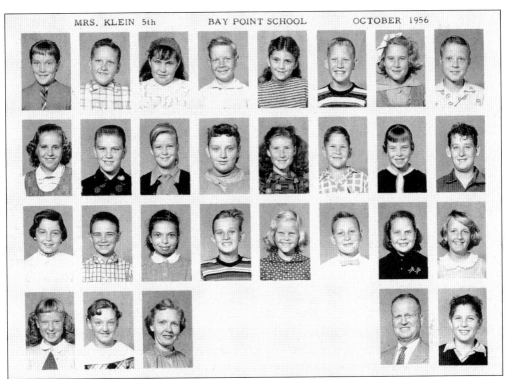

COLD WAR KIDS. The members of Mrs. Klein's fifth-grade class, pictured in 1956, appear unconcerned with rumored development and shipment of nuclear weaponry in their midst. (Courtesy Marcia Ravizza Lessley.)

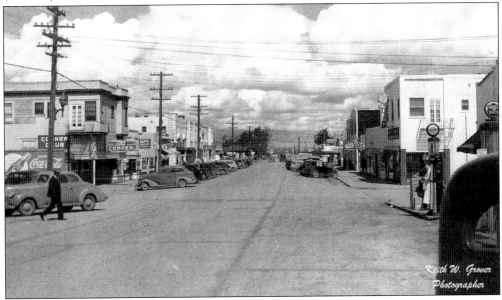

MAIN STREET, USA. This southward view of Main Street in Port Chicago was taken about 1952, a year of great decisions affecting the town. Visible businesses include, in no particular order, Ken's Shell Station, the Bank Café, the Corner Bar, the Bank Club, and the theater. (Courtesy Keith Grover.)

1968 CALENDAR. This calendar from the town's last year is a memento of the countdown of days before the people of the community were evicted from their homes. (Courtesy Bay Point Historical Society.)

COUNTRY LIVING. Dave Flori poses with his prizes after a day at the "old mallard duck club." Flori lived next to Ralph Mahoney, who was killed in Vietnam. (Courtesy Marcia Ravizza Lessley.)

WOODY GROVER COVERS PORT CHICAGO. After growing up in Port Chicago, Grover was one who chose a military career. Shown elsewhere in this book as a boy hauling World War II explosion shrapnel, here he is shown beside his F4D-1 Skyray after making his 100th aircraft carrier landing. Many from Port Chicago served in the military, despite the U.S. Navy's constant threat to their town.

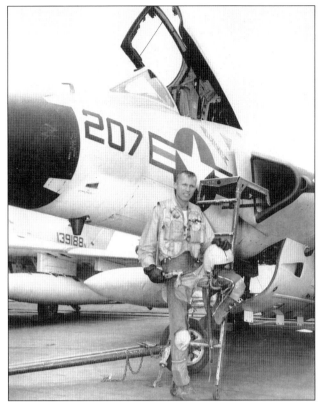

SUISUN WADERS. Reno Piva (center) and Junior Pullem (right) return from duck hunting with an unidentified friend. (Courtesy Marcia Ravizza Lessley.)

SATURDAY AFTERNOON. A number of Port Chicago residents had private duck and fishing clubs. This photograph, taken about 1955, shows a four-year-old Marcia Ravizza (in kerchief); her mother, Marie; and her father, Burt (standing). The lodge had a one-room kitchen sitting area, a separate bunkhouse to sleep 10, and an outhouse. Marcia's jobs were to ring the dinner bell and crank the Victrola. (Courtesy Marcia Ravizza Lessley.)

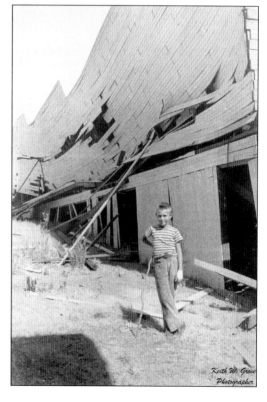

HISTORIC DAMAGE. Taken shortly after the 1944 explosion, this image shows young Woody Grover outside a damaged Port Chicago building. The once-normal town would never be so again, and its days were numbered as soon as the blast occurred. (Courtesy Keith Grover.)

FIRE STATION, 1955. The Bay Point Fire District eventually had three facilities: at Nichols, Clyde, and Port Chicago. Station No. 1 had, from left to right, a 1,000-gallon tanker with a 250-gallon-per-minute pump; a 500-gallon-per-minute pumper with a 400-gallon tank; a 750-gallon-per-minute pumper; a 600-gallon tank with an 800-pound high-pressure fog pump; and an auxiliary high-pressure truck with a 225-gallon tank and an 800-pound pressure pump for fog. (Courtesy Bay Point Historical Society.)

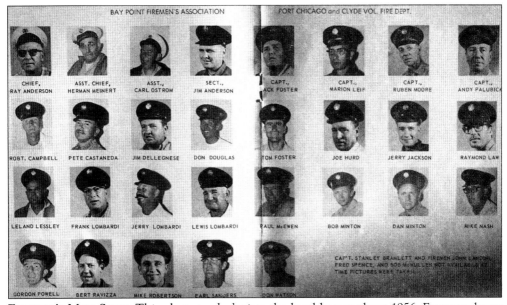

FIREMEN'S MUG SHOT. This photograph depicts the local heroes about 1956. Everyone knew someone who was a volunteer fireman. (Courtesy Bay Point Historical Society.)

MOUNT DIABLO FOOTBALL TEAM. During the middle of the 20th century, Mount Diablo in Concord was home to the high school kids of Nichols, Clyde, West Pittsburg, and Port Chicago. Its football team was known countywide. (Courtesy Dan Colchico.)

Ten

ANOTHER TRAIL OF TEARS
THE YEAR OF EVICTIONS

The year 1968 was in many ways a watershed in our nation. In Port Chicago, it was to be the year of the end. In his forthcoming book *Port Chicago Isn't There Anymore?*, author Ken Rand has written in great detail of the machinations between the U.S. Navy and the townspeople. It is a fascinating study of community activism, media intervention, and power politics. It faithfully recounts what happened to the town. The bitterness of the community over its treatment during those last two years continues to this day.

If this pictorial history has anything to contribute, it is to photographically remember the town. But perhaps importantly, it also reveals more clearly than before the actual *why* of the events that led to the disbanding of this community. In a sense, knowing the truth about the sacrifice may provide some comfort for the perceived injustice of it all. Residents were right all along that the whole thing made no sense. And yet, granted the nation's need to maintain top security surrounding its nuclear facilities during both World War II and the Cold War, perhaps there can be some closure.

This book will hopefully serve as a memorial to the sacrifice of Port Chicago, alongside the memorials of those who actually died in the wars. It was a town that died to protect its country.

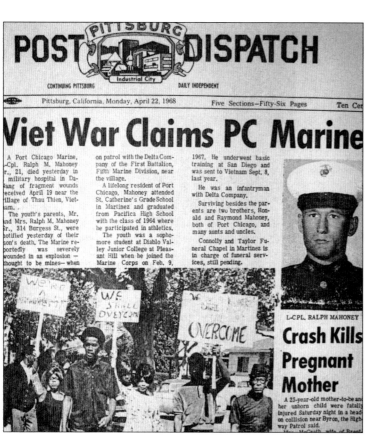

KILLED IN VIETNAM. Born and raised in Port Chicago, Ralph Mahoney died in Thau Thien, Vietnam, for his country and hometown. He was one of three casualties from the town. "Slip off that pack. Set it down by the crooked trail. Drop your steel pot alongside. Shed those magazine-ladened bandoliers away from your sweat-soaked shirt. Lay that silent weapon down and step out of the heat. Feel the soothing cool breeze right down to your soul . . . and rest forever in the shade of our love, brother. From your Nam-Band-of-Brothers-Bill Nelson." (Courtesy Bay Point Historical Society.)

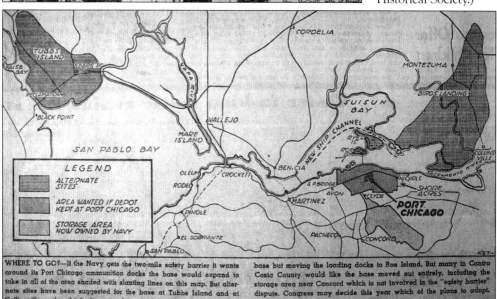

NEWS MAP OF CNWS. In the middle of the options fray for relocation possibilities, the *Contra Costa Times* prepared this graphic to show alternatives. In careful retrospect, it seems clear that other options were considered only to the extent that defenders of Port Chicago would burn out their energies in false pursuits. (Courtesy *Contra Costa Times*.)

MAIN STREET, 1968. The downtown area is pictured in its final year. Although growth had been both overtly and covertly squashed by regular media messages and direct intervention to prevent industry, the town could have survived. (Courtesy Keith Grover.)

DRILLING FOR GAS NEAR CLYDE HOTEL. Built by the Clyde Company in 1918, the Clyde Hotel was locally famous between the wars as a hunting and partying resort for celebrity types. Immediately prior to U.S. Navy possession, partners including Walter Shideler had discovered a large natural gas deposit in the swamp across the road from the hotel. It was taken. (Courtesy Marcia Ravizza Lessley.)

CONGRESSMAN JEROME WALDIE, 1967. Freshman congressman Jerome Waldie did yeoman work representing his district to the House Armed Services Committee. Praised publicly by chairman Mendel Rivers, he clearly was not privy to the top-secret nuclear weapons storage and transshipment activities of the Naval Weapons Station at Port Chicago and Concord. (Courtesy *Pittsburg Post Dispatch*.)

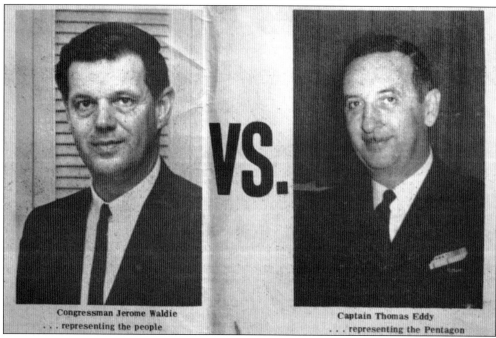

WALDIE VS. EDDY. Congressman Waldie worked tirelessly for Port Chicago, serving as the perfect David to Capt. Thomas Eddy's Goliath. The locally reviled Eddy acted out the stern, inflexible role expected of a good military officer. Placed in an untenable position, he simply carried out orders of those commanding him. (Courtesy *Pittsburg Post Dispatch*.)

THE POST PITTSBURG DISPATCH

CONTINUING PITTSBURG Industrial City DAILY INDEPENDENT

Vol. 68. No. 30 — Twelve Pages — Pittsburg, California, Monday, February 12, 1968 — Ten Cents

Waldie Fights On, But PC Buy 'In Final Stage'

Rep. Jerome R. Waldie, D-Antioch, in an informal news conference in his Concord office this morning, said he was "still pessimistic" over preventing the Navy's buying Port Chicago, but noted there were still some "possibilities" for preventing the condemnation of the community.

"I presume that the proceedings are in their final state," Waldie said, pointing out that he doubted that he would be able to talk to a conference committee of the House and Senate Armed Services Committees...

"I've been unsuccessful on two fronts," Waldie commented, referring to a recent refusal from Rep. R. Mendel Rivers, chairman of the House Armed Services Committee, to re-open his committee's hearings on the subject.

Waldie also referred to talks last week in Washington with Senator Henry M. Jackson, of the Senate Armed Services Committee.

"Senator Jackson had sympathy toward the Port Chicago..."

on another hearing.

"He said that he felt there was 'little chance' of getting the Navy's proposal reversed."

Waldie said that the matter would come up before subcommittees of the two Armed Services committees before the end of February. He said such consideration is routine in all department of defense condemnations of property over a certain figure. "However, I have not learned of these subcommittees ever reversing proceedings...

Waldie said that the subcommittes must have the condemnation proposal for 30 days, but that "to my knowledge, they have historically resolved any questions arising in that time, and approved the proposals. The Navy submitted theirs on the Port Chicago purchase last Wednesday, to get the 30-day calendar started.

"I'll appear before the subcommittees, but I have not yet conferred with the Port Chicago people as to whether or not they..."

WALDIE FIGHTS ON. This newspaper clipping illustrates one of hundreds of articles published locally over the years leading up to the "purchase" of the town. Perhaps the headline should have been, "You can fight city hall, but you can't fight the federal government." (Courtesy *Pittsburg Post Dispatch*.)

NAVAL APPRAISAL LETTER, DECEMBER 12, 1967. All property owners in Port Chicago received this letter. Part of the Congressional hearing machinations was to perform a last-ditch study of any other alternatives to the town buyout. It served the U.S. Navy's purpose to begin appraisals to bolster that study, moving the acquisition process along. (Courtesy Sierra Pacific Region, National Archives.)

```
TELEPHONE
SAN BRUNO—871-6600
AREA CODE 415

DEPARTMENT OF THE NAVY
WESTERN DIVISION
NAVAL FACILITIES ENGINEERING COMMAND
SAN BRUNO, CALIFORNIA 94066

IN REPLY REFER TO:
07-lps/am
NT/Concord/R&
12 Dec 1967

Kieth W. Grover
Louise E. Grover
Box 336
Port Chicago, Calif. 94568

Dear Mr. & Mrs. Grover:

In connection with the proposal to establish a safety zone
around the existing ammunition outloading piers of the Naval
Weapons Station, Concord, the Congress has directed that an
exhaustive study of all alternatives be conducted and the
results reported to the Congress indicating the solution
finally selected.

In support of this study, detailed appraisals are being made
of all real property within the proposed safety zone surround-
ing the existing piers.

Independent appraisers, Mr. Leslie J. Fisk and Mr. Edwin F.
Jordan, have been retained to accomplish the appraisals.

It is most desirable that the appraisers be permitted to make
a detailed inspection of your property in order to arrive at
```

REAL ESTATE OFFICE. Once it was clear that all legal avenues of escape for the town had been blocked, the U.S. Navy leased this storefront on Main Street for the convenience of townspeople and made every effort to ease the process of eviction of the community from its town. On numerous occasions those last months, the plate-glass windows had to be replaced. In another time, with a different set of people, this could have been the scene of much-greater violence. (Courtesy Laura Regester.)

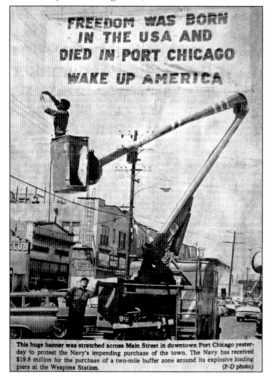

FREEDOM IN PORT CHICAGO. This banner hung above Main Street in the last months of its civil existence. The town, known for its patriotism, found itself in the unenviable position of impotently creating signs and posters to protest its own destruction. (Courtesy *Pittsburg Post Dispatch*.)

THE GRAND DAME OF PORT CHICAGO. Eunice Van Winkle, the granddaughter of Calaveras County rancher Nathaniel Beale, settled in Port Chicago with her husband, Walter, around 1918. They were far and above the principal business and property owners of the town from the Depression until the taking of 1968. Here Eunice takes the bullhorn in a final ritual of freedom of expression. (Courtesy *Pittsburg Post Dispatch*.)

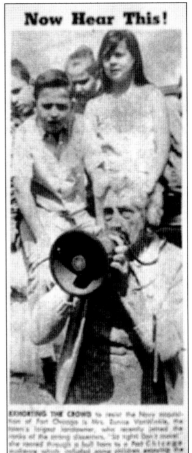

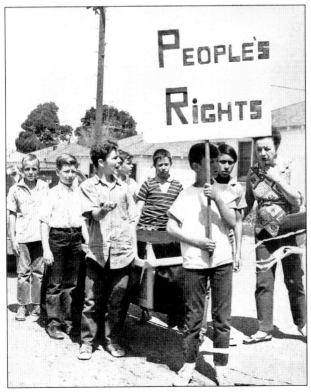

THE LAST EASTER PARADE, APRIL 13, 1968. For 24 years, the Lions Club had sponsored the Port Chicago Easter parade. The lone protest marchers were these seven Port Chicago boys carrying a coffin entitled "People's Rights." (Courtesy Marcia Ravizza Lessley.)

PROTESTERS. At Easter break in 1968, some of the town's college students added their protests to that of their parents. These young people can truly "never go home again." (Courtesy *Pittsburg Post Dispatch*.)

DAN COLCHICO DEFENDS HIS HOME. Ignoring the sign on his gate reading "No Trespassing. Unauthorized Violators Will Be Shot," U.S. Deputy Marshal Richard St. Germain and another deputy were greeted by San Francisco 49er Dan Colchico and his Winchester rifle. The authorities withdrew carefully that day, before the anniversary of D-Day. (Courtesy *Contra Costa Times*.)

COLCHICO FAMILY. This photograph of the Dan Colchico family was taken from a San Francisco 49er football program. A favorite son of the town, Colchico bears the emotional scars of a man betrayed by his country. (Courtesy Dan Colchico.)

NAVY OFFER TO BIDELMANS. This letter demonstrates the reality faced by all homeowners of the town. Terry Bidelman was the last man to leave his residence, just in front of the bulldozer that leveled his home. (Courtesy Laura Regester.)

"U.S.N. STINKS." In an editorial comment on his garage door, Terry Bidelman expressed his bitterness. Given the heroic history of the U.S. Navy in defending the country, this was one of its least-appreciated victories locally. (Courtesy Laura Regester.)

CATHOLIC CHURCH TO MOVE. Among the cultural icons removed from town was Mission St. Francis of Rome Catholic Church, built in 1912. Loretto Tormey and John Vlach were the first couple married in the church. The U.S. Navy did not destroy the structure immediately. Plans in April 1975 were to sell it to the Bethel Baptist Church on Bethel Island. (Courtesy Laura Regester.)

GOING HOMES. Those who refused to sell their homes to the U.S. Navy had the option of transporting them. Many took the opportunity and moved to nearby West Pittsburg, Clyde, Concord, and other communities. Great efforts were made by the chambers of commerce of the nearby cities of Contra Costa to make the displaced feel welcome. Early on, the chambers had recognized the wisdom of having one less growing community in their midst. (Courtesy Bay Point Historical Society.)

UNCLE SAM'S BOOTS. This political cartoon, drawn by a Port Chicago high school student, may have led to a budding career for the young artist. Perhaps the larger view of the history of the town in relation to the national interest could eventually soften the townspeople's distress. Perhaps not. (Courtesy *Concord Transcript*.)

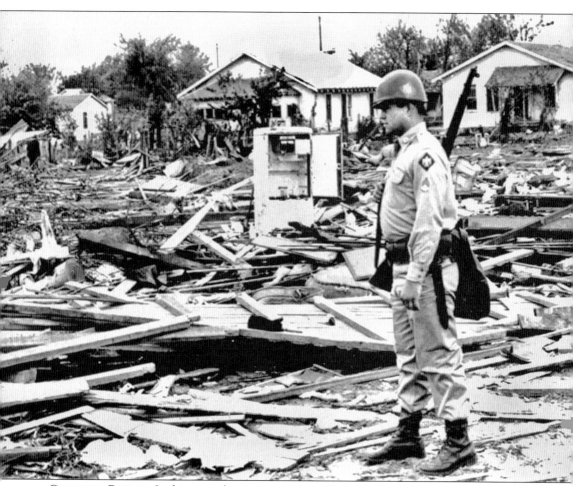

GUARDING RUBBLE. In this somewhat ironic view, a military guard stands watch over a demolished street during the evictions of 1969. Most people decided to take the U.S. Navy's offer to purchase their homes, while a few were able to move their houses. It was a no-win situation.

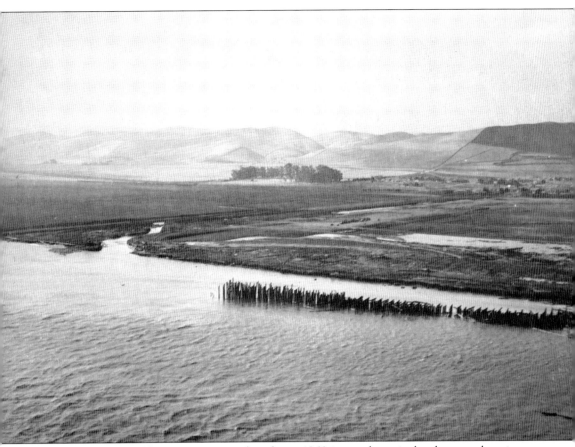

PRETTY TOWN. Port Chicago is no more, but this c. 1960 image shows its lovely natural setting alongside the pilings of the former pier, where the 1944 explosion occurred. (Courtesy Sierra Pacific Region, National Archives.)

Across America, People are Discovering Something Wonderful. Their Heritage.

Arcadia Publishing is the leading local history publisher in the United States. With more than 3,000 titles in print and hundreds of new titles released every year, Arcadia has extensive specialized experience chronicling the history of communities and celebrating America's hidden stories, bringing to life the people, places, and events from the past. To discover the history of other communities across the nation, please visit:

www.arcadiapublishing.com

Customized search tools allow you to find regional history books about the town where you grew up, the cities where your friends and family live, the town where your parents met, or even that retirement spot you've been dreaming about.